Full Light and Perfect Shadow
The Photography of Chao-Chen Yang

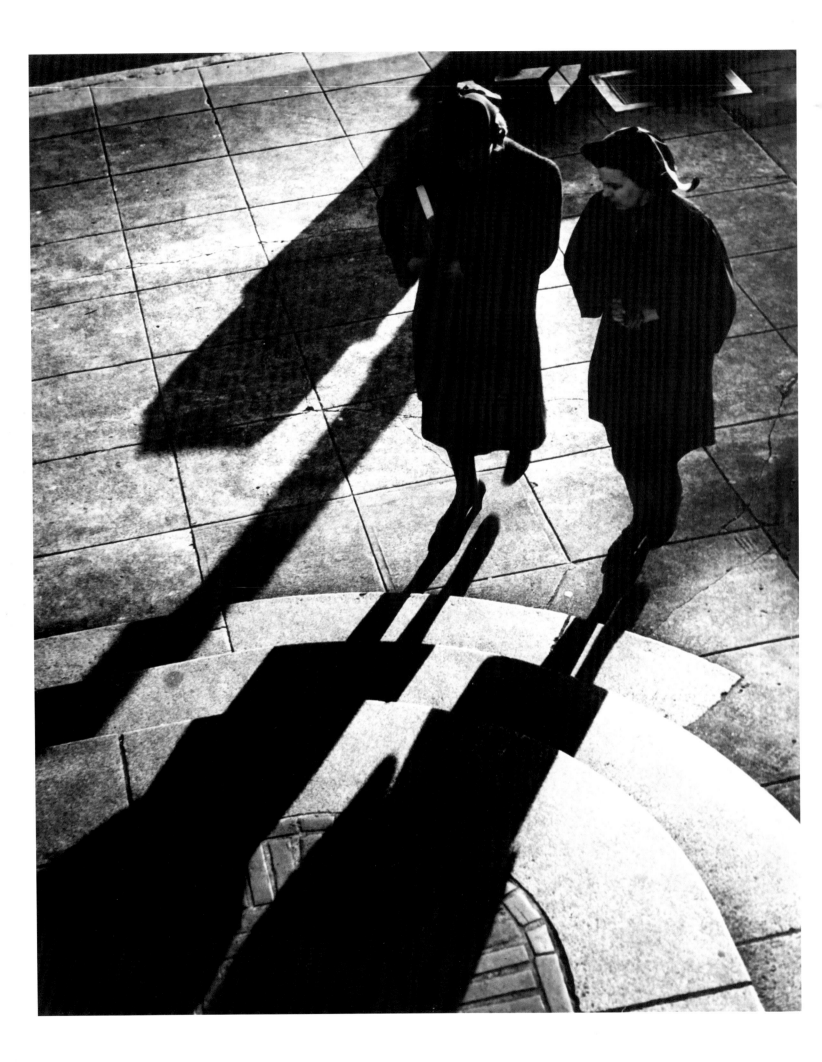

Full Light and Perfect Shadow
The Photography of Chao-Chen Yang

David F. Martin

CASCADIA ART MUSEUM

DISTRIBUTED BY UNIVERSITY OF WASHINGTON PRESS

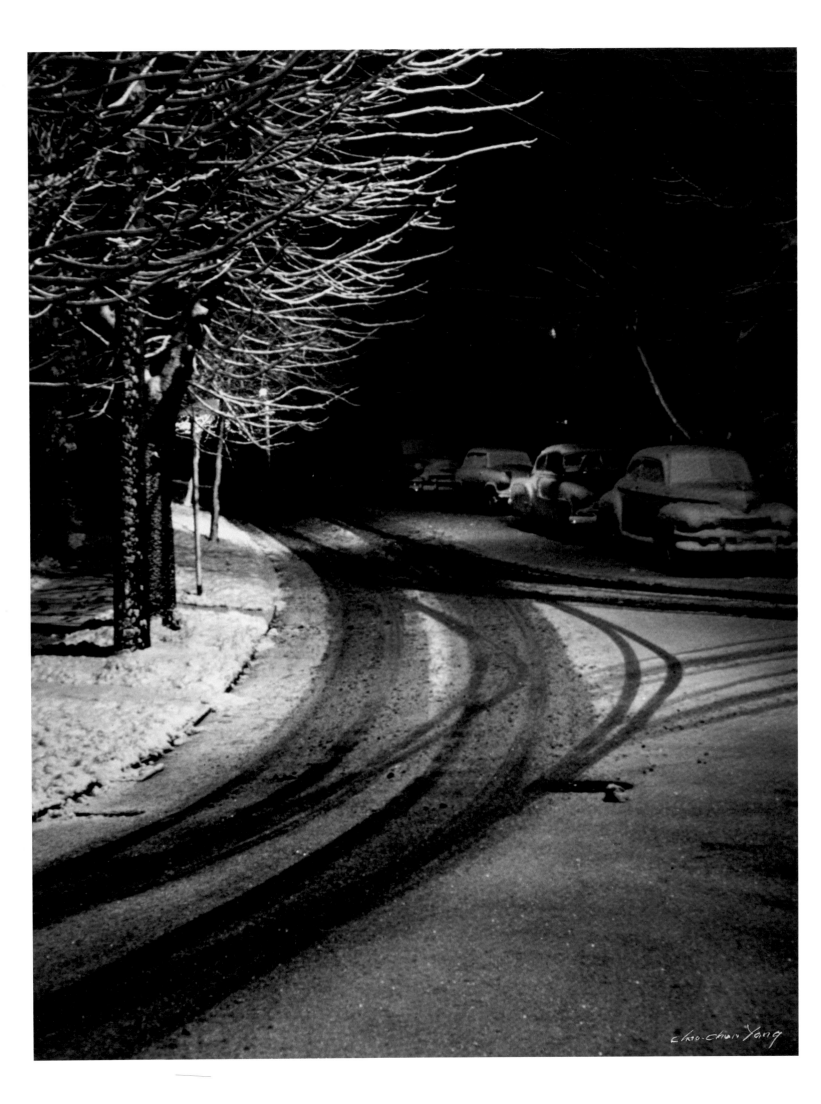

Contents

Chao-Chen Yang (1909–1969)
Winter Street, 1961
Dye Transfer print
19 ¾ × 15 ½ in.

Foreword

CASCADIA ART MUSEUM IS PLEASED TO PRESENT the publication *Full Light and Perfect Shadow: The Photography of Chao-Chen Yang* and the accompanying exhibition. Both efforts, written and curated by our museum curator David F. Martin, lend new and important scholarship to the work of Chao-Chen Yang and his contemporaries. Through careful research, this publication brings together a comprehensive understanding of Yang's inspirations, hardships, and artistic techniques. As the title indicates, both light and shadow were present in Yang's life and can be seen in the legacy of his photographs.

Our mission at Cascadia focuses attention on Northwest artists from 1870 to 1970. With a commitment to artistic exploration and historical preservation, we seek to give voice to the under-recognized artists of our past. Artists such as Chao-Chen Yang made deep contributions to our regional cultural identity, and the museum is proud to play a role in the rediscovery of this important artist.

During Yang's lifetime, he encountered challenges and adversities. He left China as a young man, never to see his parents again (or know what became of them). As an Asian immigrant in the United States during World War II, he encountered racism and exclusion. Later in life, as his health deteriorated from kidney disease, through his strong faith and the kindness of friends he was able to meet these obstacles with resilience and determination. He never gave up. Through his personal adversity, he continued to create photographs that portrayed hope rather than bitterness. Yang's photography is a testament to the human capacity for empathy and growth. His innate talent and his resolve to keep taking photos leaves us with a body of work that is to be celebrated and enjoyed.

We are proud to partner once again with the University of Washington Press and extend heartfelt gratitude to our loyal donors and supporters whose generosity brought this important publication to fruition.

Sally Ralston
Executive Director
Cascadia Art Museum

Chao-Chen Yang (1909–1969)
Night in Paris Street, 1955–56
Dye Transfer print
13 ½ × 19 ⅜ in.

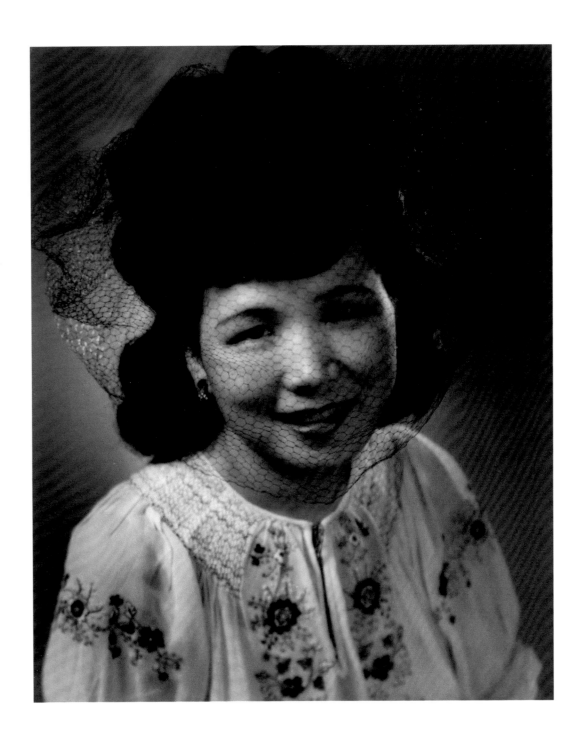

Introduction

BACK IN THE LATE 1980s, I befriended an amazing man named John D. "Jack" McLauchlan Jr. Although he was an attorney by profession, McLauchlan was an excellent photographer and had been involved in the Seattle art scene since the 1930s. His wife, Ebba Rapp, was one of the most talented artists in the region and founded the sculpture department at Seattle's Cornish School around 1935. McLauchlan really educated me about the region's early photographers, since he was a friend to many of them. On one occasion, we visited a close friend of his, Jean Yang, whose husband was the late Chao-Chen Yang, whom I was soon to discover was an enormous hidden talent. McLauchlan encouraged me to document Yang's photographic career, and when we visited Jean on several other occasions, she allowed me to look through the family's collection. After Jean passed away in 2008 at age 102, I became better acquainted with her son, Edgar, and his wife, Linda. In 2022, Edgar and his family gifted Cascadia Art Museum with his father's collection. Several duplicates of the photographs were also generously donated to a few major art museums in the United States and Europe. With the museum the repository for Chao-Chen Yang's art, our board decided to produce this book to document his life and work and to fulfill Jean's wishes.

When I began the initial research, I found inconsistencies in some of the published materials in public archives as well as in family recollections. For instance, some sources list the date of Yang's birth as 1909 and others as 1910. After locating two documents and one dated family film, I am now certain he was born in 1909. If I was unable to document the exact dates for his photographs, I listed a range of within a few years. I was also able to establish a chronology to document which works were created in Chicago, Seattle, and various locations in Europe. Since Yang experimented with different photographic processes, I have listed what I know is accurate, and for those that are not identifiable, I simply listed the process as unknown.

All of the Chao-Chen Yang photographs in this book, except where otherwise noted, are currently under our accession process as gifts to Cascadia Art Museum's permanent collection from the Edgar Yang family.

I was extremely touched by the care that Chao-Chen Yang received in the final years of his life as he struggled with advanced kidney disease. Jean, Edgar, and Linda made great sacrifices to assist him in his grueling, early dialysis treatments and the consequential stress that accompanied the demands of the terminal illness of a loved one.

This book is dedicated to the memory of Jean Yang, whose selfless support, care, and encouragement of her husband made his art and career a reality.

David F. Martin

Chao-Chen Yang (1909–1969)
Jean, 1948
Chlorobromide
16 ¾ × 13 ⅞ in.

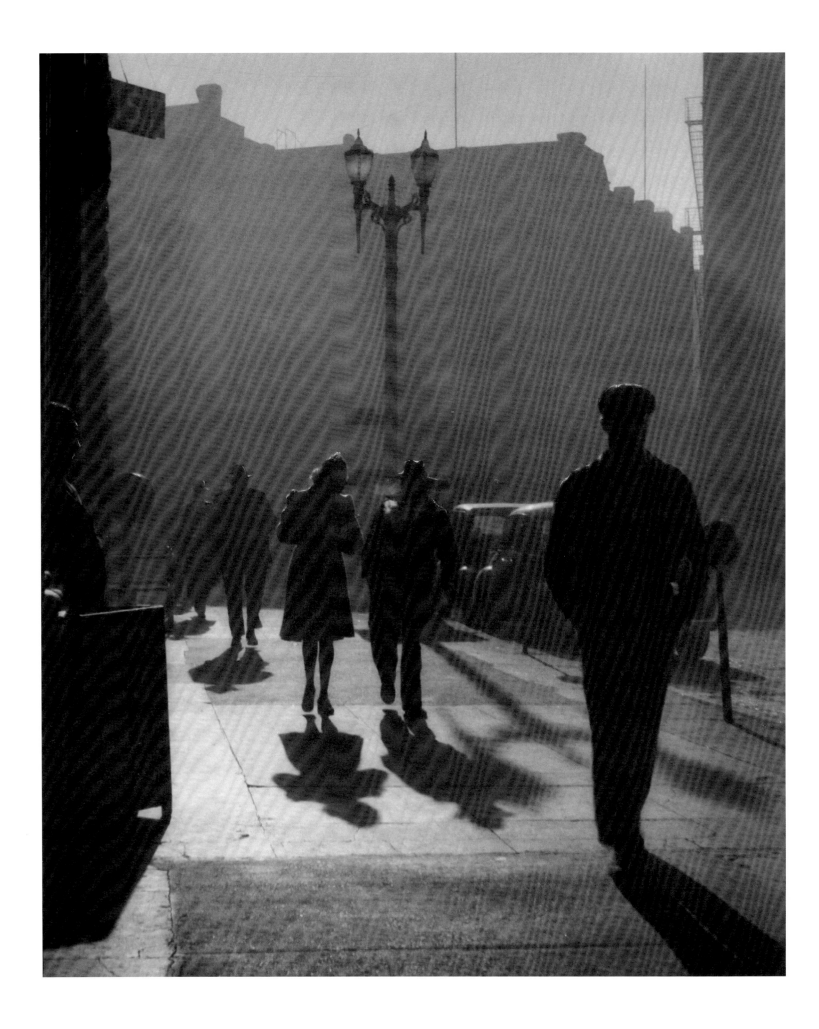

Full Light and Perfect Shadow:
The Photography of Chao-Chen Yang

David F. Martin

SEATTLE'S HISTORY OF CHINESE IMMIGRATION is as varied and checkered as the stories of most immigrants starting a new life in a foreign country. Many came to the Northwest in search of gold, but most ended up working to build the intercontinental railway under slave-like conditions and suffering through the ramifications of the "Yellow Peril" propaganda. Racist attacks on Chinese immigrants by hate groups in 1886 drove many out of larger cities such as Tacoma and Seattle, Washington, and the following year, thirty-one Chinese miners were murdered along the Oregon-Idaho border.[1]

However, the cultural and artistic integration of Chinese immigrants in Seattle appears to have been heading in a more positive direction by the early twentieth century. One individual who played an important role in both the cultural and economic growth of Seattle and Portland, Oregon, was Goon Dip (1862–1933) (fig. 1). Coming from humble beginnings, he left his native China at the age of fourteen with a dream of achieving economic security and social status through the promise of the gold rush. Arriving initially in Portland, where several family members had previously emigrated, the intelligent and hardworking young man was met with opportunities as well as anti-Chinese racism. A changing point in his life occurred when he met a young woman named Ella E. McBride (1862–1965), who was teaching English at a local missionary school, and the two developed a close friendship. Eager to assist her new friend out of his dire situation, she persuaded her parents to invite him into their home. He earned his keep by assisting the family with daily household chores, while she expanded his command of the English language. After spending a few years as a laborer in Portland and Tacoma, he returned to China at his family's insistence, to protect him from the growing threat of racist violence. When he returned to China, he married a woman named Chin Yook-Nui, whose family had ties to the Pacific Northwest. The couple moved to Oregon around 1878. After several years of struggle and hard work, and with the assistance of his wife's prosperous family in Seattle, Goon Dip became an extremely successful businessman in the Northwest, building his fortune as a labor contractor, property developer, and retail entrepreneur. In 1908, he followed Ella McBride's move to Seattle, where in 1909 he worked at the Alaska-Yukon-Pacific Exposition. McBride was now managing the photography studio of Edward S. Curtis (1868–1952), whom she met climbing Mount Rainier in 1897. For the exposition, Goon Dip was appointed honorary Chinese consul, and through his importing of antiquities and other precious objects presented at this important event, he advanced the public's understanding and appreciation of his culture. When the fair ended, he maintained the consul position for many years.

Chao-Chen Yang (1909–1969)
Misty Morning, circa 1939
Chlorobromide
12 ¾ × 10 ⅝ in.

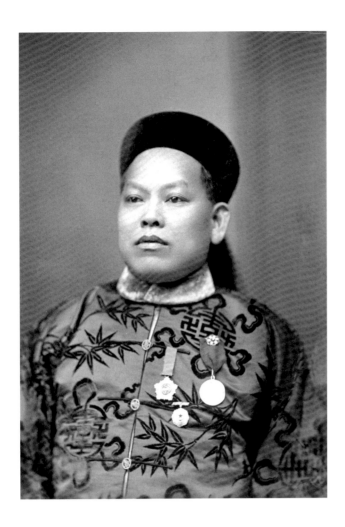

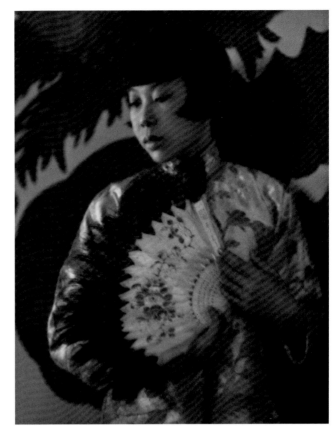

McBride developed into one of the region's finest photographers. Along with her business partner, Wayne C. Albee (1882–1937), she ran the McBride Studio, which opened in 1915 and became the region's cultural nexus over the next few decades. The studio worked closely with the Cornish School of the Arts and other institutions to document not only the region's cultural activities but also important visiting figures from outside the area. The studio employed brilliant photographers such as Frank Asakichi Kunishige (1878–1960) and Soichi Sunami (1885–1971) for the highest quality work, which reached an international audience. Goon Dip honored his beloved friend by naming his youngest daughter Ella McBride Goon in 1904 (fig. 2).[2]

Another interesting figure in Seattle's ties to China was the activist and writer Anna Louise Strong (1885–1970) (fig. 3). A Seattle resident from 1910 to 1921, Strong was dedicated to children's welfare and education. After covering the 1916 Everett Massacre for the *New York Post*, she focused her efforts on labor rights. Numerous workers and law enforcement agents were killed in the conflict in Everett, Washington, between members of the Industrial Workers of the World union, known as the "Wobblies," and violent business owners and their sympathetic cohorts in law enforcement. In 1921, disillusioned with the labor movement in the United States, Strong moved to Moscow, Russia, and wrote articles for progressive American newspapers. She visited China in 1925, 1927, and 1937 and conducted the famous 1946 "paper tiger" interview with Mao Tse-tung. In 1958, she moved permanently to China and continued her career as a journalist. She died there in 1970.[3]

Two important figures in the history of Hollywood also had their roots in Washington State. Chinese-born James Wong Howe (Wong Tung Jim, 1899–1976) immigrated to the

fig. 1. Unidentified photographer
Portrait of Goon Dip, 1908
Courtesy of Wing Luke Museum of the Asian Pacific American Experience

fig. 2. Wayne C. Albee (1882–1937)
The Daughter of Goon Dip, circa 1922
Gelatin silver
9½ × 7½ in.
Private collection

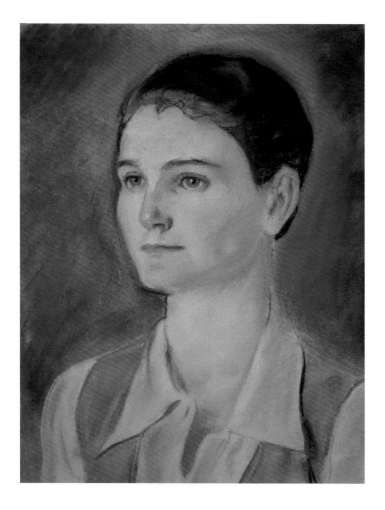

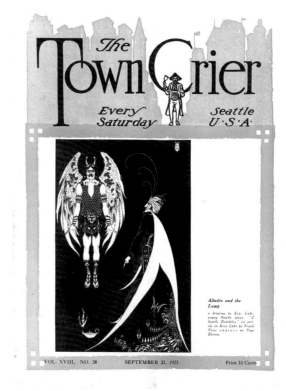

fig. 3. Mabel Lisle Ducasse
(1895–1976)
Portrait of Anna Louise Strong,
circa 1918
Pastel
12 ½ × 9 ⅞ in.
Private collection

fig. 4. Cover of *The Town Crier*
magazine featuring Keye Luke's
drawing *Aladdin & the Lamp*,
vol. 18, no. 38 (September 22, 1923).
Martin-Zambito archive, Seattle, WA

United States at the age of five and was raised in Pasco, Washington. After the death of his father, he moved to Oregon, where for a few years he earned his income as a bantamweight boxer. By 1917, he moved to Hollywood and became assistant to director Cecil B. DeMille. Under DeMille's guidance, he produced numerous movie stills using his ever-increasing talent as a photographer. He became one of the movie industry's leading cinematographers, until being unjustly "gray-listed" as a Communist sympathizer during the McCarthy era, causing severe damage to his professional career.[4]

Unknown to many people is the Seattle connection of the actor Keye Luke (1904–1991). Born in Guangzhou, China, Luke moved with his family to Seattle at the age of three. Determined to become a fine artist, he produced numerous high-quality illustrations for his Franklin High School yearbook. He developed a style that caused him to be dubbed "Seattle's Beardsley," due to the resemblance of his work to that of the famous British illustrator Aubrey Beardsley (1872–1898). Luke was also inspired by local artist John Davidson Butler (1890–1976) and Tacoma's Mac Harshberger (1901–1975), who also produced beautiful ink drawings in the manner of Beardsley (fig. 4). Luke became an admired member of Seattle's art community and briefly attended the University of Washington to study architecture, while earning a living doing commercial art and decorative murals. He befriended artists such as Ella McBride, who produced headshots for the talented young man after he moved to Los Angeles in 1927. While trying to attain a profession in the fine arts, he pursued an acting career, for which he became world famous, most notably for portraying the "Number One Son" in the Charlie Chan series of the 1930s. When he arrived in Hollywood, he used

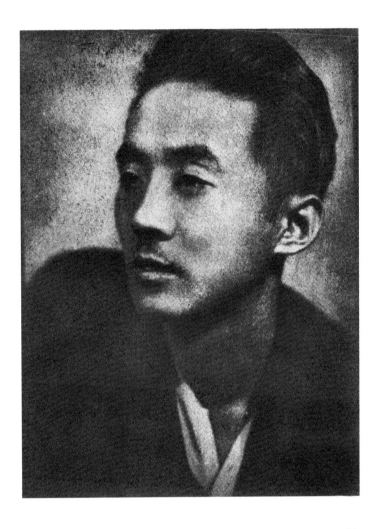

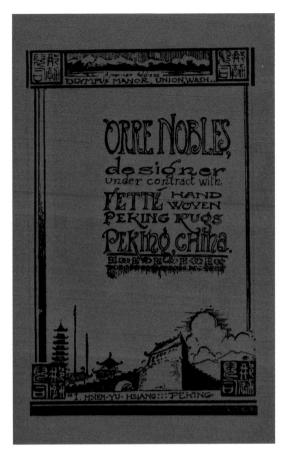

fig. 5. Virna Haffer (1899–1974)
Portrait of Kwei Dun, circa 1929
Bromoil transfer print
9 ¼ × 7 ⁹⁄₁₆ in.
Virna Haffer Collection, Northwest
Room at Tacoma Public Library

fig. 6. Orre Nobles's business card as
designer for the Fette-Li Company,
1930 (recto)
Martin-Zambito archive, Seattle, WA

his artistic skills mostly for movie advertising, for classic films such as *King Kong* and *The Good Earth*, in which he also played the character of the elder son. He also created excellent portraits of some of the leading actors of the period.[5]

Another Chinese artist who attended the University of Washington at the same time as Luke was Kwei Dun (fig. 5), now known as Teng Baiye (1900–1980). Dun became part of Seattle's art community for the unusual talent of finger painting as well as sculpture. He formed close friendships with some of the leading modernist figures in the area, including the photographer Virna Haffer (1899–1974), who created several intriguing portraits of him during the time they were lovers. He also befriended the artist Mark Tobey (1890–1976), who became enthralled by the young artist's talent and personality and studied calligraphy with him at the University of Washington, where Dun taught after graduating in 1927. Tobey would visit Dun in China and Japan for further studies, and his close association with him was likely the source for Tobey's calligraphic style of abstraction, today known as "white writing."[6]

An intriguing tie to China occurred when several gay Northwest artists traveled or relocated there in order to pursue their interests in Chinese art and culture as well as to seek a more relaxed atmosphere to pursue sexual and emotional same-sex relationships. Orre Nelson Nobles (1894–1967) began working on a tramp steamer to raise money to allow him to attend the Pratt Institute in Brooklyn, New York. Between 1917 and 1919, he visited Japan and China, getting his first taste of the enduring fascination he held for these countries. He became a beloved local art instructor in Seattle's public school system and created a utopian artistic refuge on the shores of Hood Canal in Washington State. In 1927, he met

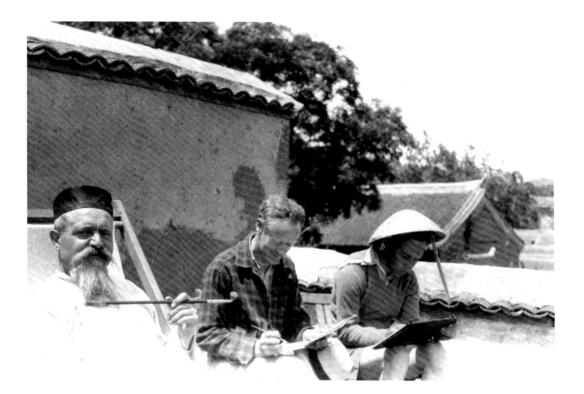

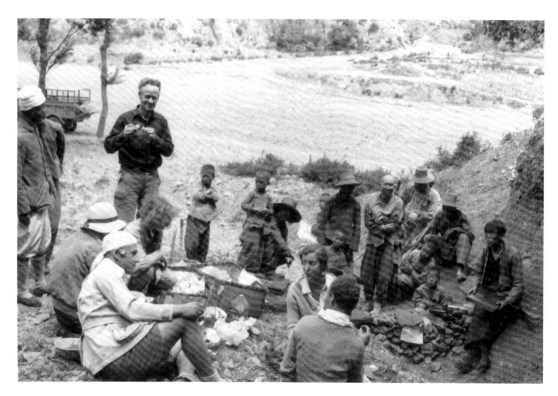

the visiting world heavyweight boxing champion Gene Tunney (1897–1978), who was in
Seattle presenting a lecture. The two men developed a close, intimate friendship, which was
maintained when Tunney returned to the East Coast. When Tunney married in 1928, Nobles
was heartbroken and returned to Southeast Asia in 1929, accompanied by a former student.
They visited Japan, Korea, and Manchuria, before settling in Peking. With the intention of
an extended stay in China, Nobles became the chief designer for the Fette-Li looms and over
the next year designed more than 125 rugs in the traditional and art deco modernist styles for
export throughout the world (fig. 6). In 1931, when Nobles was getting ready to move on, his

close friend from high school in Tacoma, Thomas Handforth (1897–1948), arrived in China on a Guggenheim Fellowship.

This group of gay men traveled throughout China and other locations (figs. 7, 8) and included Harold Acton (1904–1994) and Laurence Sickman (1906–1988), who would become Handforth's lover. Sickman would go on to become a leading scholar of Chinese art and antiquities at the Nelson-Atkins Museum of Art in Kansas City, Missouri. Besides his career in the arts, Sickman had a distinguished military career during World War II and was one of the legendary Monuments Men who rescued numerous cultural objects and works of art during the war.[7] Handforth took over Nobles's apartment, although he described it personally as a "palace," which he filled with fine antiques, paintings, and textiles.

The peripatetic Handforth had been traveling for years while studying, creating, and exhibiting art in London, Paris, and other large European cities, as well as the United States. He was internationally known as one of the finest printmakers of his day, concentrating primarily on etching and other intaglio methods (fig. 9). His work was collected in numerous major American art museums, but he sought new forms of expression after arriving in China. He taught himself the art of lithography and purchased a press and stones to create new effects that could not be achieved with etching: "My goal in etching and lithography is to do, without imitating its technical manner, a Western *Hsie-y*, i.e. 'to write the meaning.' (The Chinese *Hsie-y* is closely related to Chinese calligraphy.) The rhythm of *Hsie-y* is not contained within the frame. What is visible is only like the fragment of a melody carried in and out of the picture frame toward infinity on a two-dimension plane."[8] Handforth remained in China from 1931 until he was forced to leave due to the Japanese invasion. He hid his lithography press inside the walls of his "palace" but was never to return to China again. Before leaving, he produced an extremely unsettling image of beheadings at Peking Square in 1936 titled *Execution*, a dark and disturbing end to the numerous inspired images that he produced in China (fig. 10). Handforth revisited the happier period of his life when he produced a children's book titled *Mei Li*, published in 1938. Now considered a breakthrough in the advancement of minority inclusion in children's literature, Handforth's *Mei Li* won the prestigious Caldecott Medal for illustration in 1939.

The year 1933 was an important one in Seattle. Goon Dip had died, leaving his position as honorary Chinese consul vacant. It also saw the construction and opening of the Seattle Art Museum, the leading cultural and artistic venue in the city. In the Midwest, the world was enthralled with the Century of Progress International Exposition, the Chicago World's Fair that opened that year as well. Although China did not send a delegation or participate in the funding of its pavilion at the fair, several prominent Chinese figures became involved. One such person was Chao-Chen Yang (1909–1969). Born in Hangzhou, China, to Episcopal Christian missionaries, he was one of four children (fig. 11). His parents barely survived the Boxer Rebellion, carried out by the Society of Righteous and Harmonious Fists between 1899 and 1901. This anti-colonialist, anti-Christian organization murdered numerous foreigners and Christians living in China at that time. Yang studied at the Hangzhou mission school, where his mother taught piano and organ. Previously, she was dean of the mission's girls' school for twenty-six years. He then received his art training at the Sing Hwa Arts Academy in Shanghai, graduating in 1926. He began to question his belief system and started having anti-Christian, anti-foreign sentiments himself, much to the dismay of his parents. After a

fig. 9. Thomas Handforth (1897–1948)
Pekin Camels, 1936
Etching
7 ⅞ × 8 in. (plate)
Cascadia Art Museum
Margaret Nannie Hartzell Collection
CAM 2021.13.142

fig. 10. Thomas Handforth
(1897–1948)
Execution, 1936
Lithograph
12 ⅞ × 20 in. (sheet)
Cascadia Art Museum
Margaret Nannie Hartzell Collection
CAM 2021.13.180

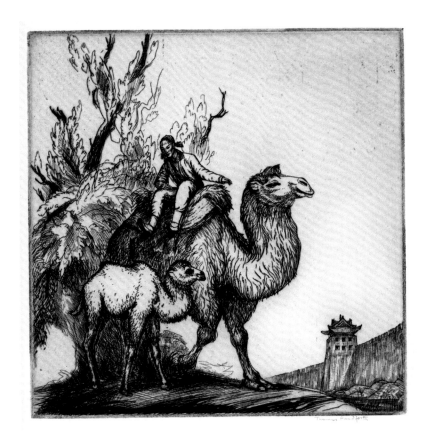

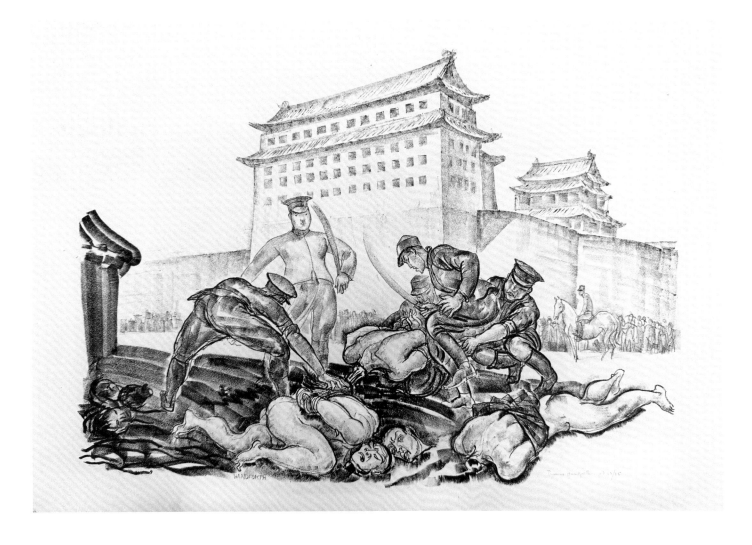

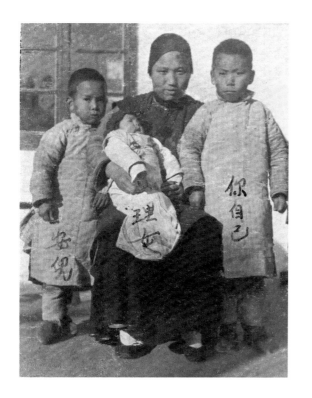

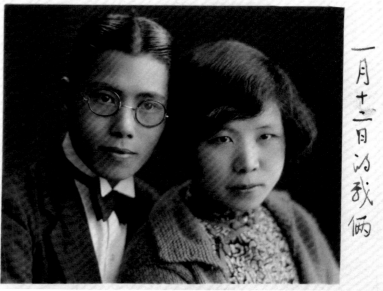

short period, he reconnected with his Christian beliefs and nationalist fervor. After gradu-ating, he joined the revolutionary movement of Chiang Kai-shek (1887–1975), serving from 1926 through 1928 as a captain in the Chinese army along with his older brother. After com-pleting his military service, Yang worked for the Government Institute of Nanking, where he taught history and literature and became the art director of the school. He served as editor of *Literature* magazine and wrote about contemporary art in China for several publications. After completing the required courses, he passed the exams for entering the Chinese diplo-matic service. While teaching at the institute in Nanking, he met fellow instructor Sun Dzing-Tsoh (1906–2008), with whom he fell in love. Sun, later known by her American name, Jean, had her own impressive career. She also graduated from the same university in Shanghai and taught at the Yi-Tsu School, founded by the wife of Chiang Kai-shek, Soong Mei-ling (1898–2003), the US-educated First Lady of the Republic of China. Jean and Chao-Chen were engaged in China on January 12, 1932, and married a few months later, on May 18 (figs. 12, 13). Within a year, they had a baby girl, named Ba Yih. He had an uncle who was serving as consul general in Chicago at this time, and he arranged to have his nephew join him for an intended temporary period in the United States as his assistant.

He arrived in Chicago without Jean on February 28, 1933. Their baby daughter was only four days old when he left China. Yang served as chancellor of the Chinese Consulate General. He participated in the Chinese cultural presentations at the Chicago World's Fair, as well as continuing his activities with the Boy Scouts organization, which he was deeply involved with in China. Jean would join him in Chicago in 1934, after one year of separation,

fig. 11. Chao-Chen Yang (*right*) with his mother, younger brother, An (*on the left*), and sister, Li, on his mother's lap, circa 1915. An older brother is not included in the photo. Courtesy of Edgar Yang

fig. 12. Chao-Chen and Jean's engagement photograph, January 12, 1932 Courtesy of Edgar Yang

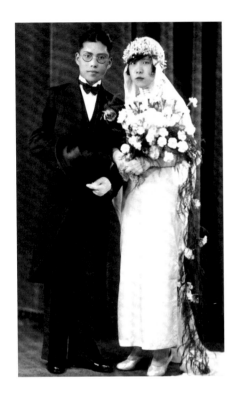

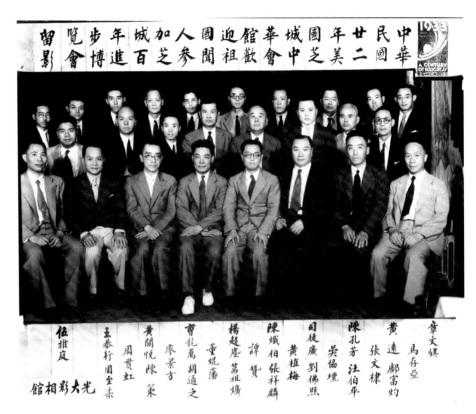

fig. 13. Chao-Chen and Jean's wedding photograph, May 18, 1932 Courtesy of Edgar Yang

fig. 14. Top text: The Chicago Chinese Association of the United States welcomes distinguished individuals from China to the Chicago Centennial Progress World's Fair in the 22nd year of the Republic of China (1933).

Bottom text: Wen-Qi Zhang, Cun-Ya Ma, Yuan Huang, Fu-Zhuo Kuang, Wen-Di Zhang, Kong-Fang Chen, Bo-Ping Wang, Xie-Xun Wu, Guang Situ, Fo-Zhao Liu, Zhi-Mei Huang, Chi-Bo Chen, Xiang-Lin Zhang, Zan Tan, Chao-Chen Yang, Zu-Kuang Ge, Kun-Fan Dong, Long-Wan Cao, Shi-Zhi Hu, Jing-Fang Liao, Guan-Yue Huang, Ce Chen, Guan-Hong Zhou, Gong-Xing Wang, Zhi-Rou Zhou, Ya-Ting Wu.

Guang-Da Photography Studio Courtesy of Edgar Yang

leaving their baby girl in the care of her parents. His involvement in the world's fair was through the Chicago Chinese Association of the United States, in the fair's Fujian Province showroom (figs. 14, 15). Yang began taking night classes at the Art Institute of Chicago in 1933 and continued through early 1939.[9] He studied drawing, painting, and sculpture with various instructors and photography with Don Loving (1920–1973).

The fair had several art-related exhibitions, most notably the International Photographic Salon, sponsored by the Chicago Camera Club (fig. 16). Chicago had long boasted one of the most active and successful camera clubs in the country, and Yang, with his new interest in photography, would certainly have attended. The exhibition is noted for the inclusion of photographers working in a wide array of styles, from traditional pictorialism to modernism. The latest advancements in outer space photography were provided by the Mount Wilson Observatory in California, and medical photography was represented by a bizarre x-ray print of a skull supplied by the Eastman Kodak Company's Research Laboratory. Titled *Portrait of a Splitting Headache*, the x-ray documented an infected nasal sinus. The 436 participants represented some of the leading photographers of the day, including Edward Steichen and Dorothea Lange. Three photographers from China were represented as well, Chung Hsin Wu and Chuen-Lin Chen, both from Shanghai, and Onn M. Liang from Canton. Two exhibitors would soon play an important role in Yang's development as an artistic photographer, California's William Mortensen and Seattle's Yukio Morinaga (fig. 17).

Probably the most famous art associated with the fair was the sculpture series by Malvina Hoffman (1885–1966) titled *The Races of Mankind*, commissioned by Chicago's Field

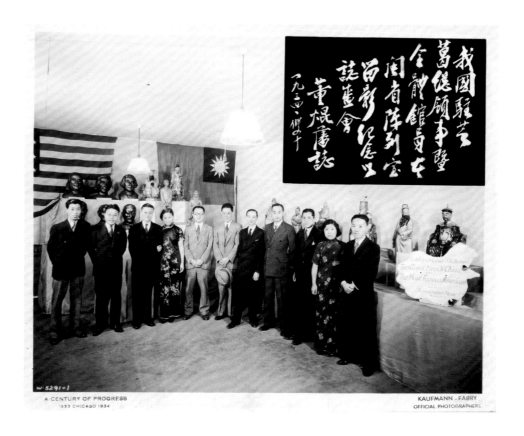

A CENTURY OF PROGRESS
1933 CHICAGO 1934

KAUFMANN - FABRY
OFFICIAL PHOTOGRAPHERS

fig. 15. The Chinese Consulate General in Chicago, together with all consulate staff, had a photo taken in the Fujian Province showroom to commemorate the event. Chao-Chen Yang is standing, third from the right. Translation: "Written by Kun-Fan Dong, Double Tenth Day in 1934 (Double Ten Day is October 10, which is the National Day of the Republic of China)."
Courtesy of Edgar Yang

fig. 16. Exhibition label from the International Photographic Salon, 1933, A Century of Progress, Chicago World's Fair, Chicago Camera Club. Martin-Zambito archive, Seattle, WA

fig. 17. Yukio Morinaga (1888–1968) *Plegaria*, circa 1928 Bromide print Private collection

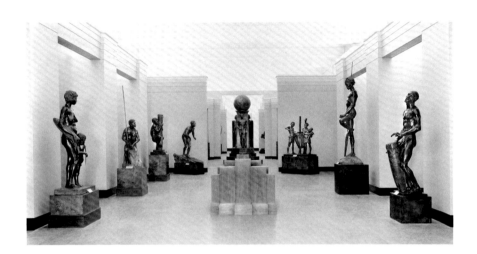

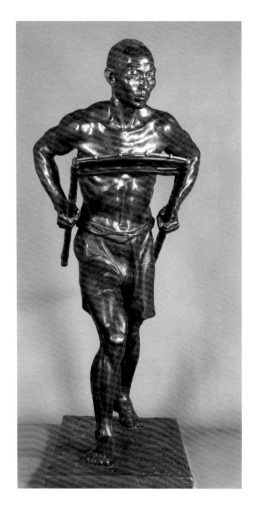

fig. 18. First Gallery of the Hall of Man, Field Museum, Chicago, 1933
© Field Museum, Image No. GN78455

fig. 19. Malvina Hoffman (1885–1966)
Chow Fu, Chinese Jinrikisha Driver, 1931
The Races of Mankind
Bronze
Photography by Shelley M. Smith
Field Museum, Anthropology Collections, Chicago
© Field Museum, Cat. No. 337036

Museum, which was next to the fairgrounds site. Hoffman invested several years of detailed studies of people of different ethnic origins to create a racial "type," which was not uncommon in American art of that period. A photographic series by Caroline Haskins Gurrey (1878–1927) displayed at Seattle's 1909 Alaska-Yukon-Pacific Exposition featured fifty pictorialist photographic portraits of mixed-race Native Hawaiians, and a few works from the series were also featured in the 1915 Panama-Pacific International Exposition in San Francisco. Whether these types of work were misguided as seen through a modern point of view, the original intention was to foster understanding of ethnic diversity and unfamiliar cultures.

One of the Hoffman sculptures, titled *Chow Fu, Chinese Jinrikisha Driver*, was created to represent aspects of that culture and socioeconomic structure. Whether members of these individual ethnic groups found the sculptures insulting or felt a sense of pride can never be known, but it was likely a mixture of both. At the very least, the sculptures provided representation and a touchstone for potential advancement (figs. 18, 19). These attempts to express a positive racial or social archetype were just beginning to enter the American imagination through books such as Pearl S. Buck's *The Good Earth*. It was the best-selling novel in the United States in both 1931 and 1932 and won the Pulitzer Prize for Fiction in 1932. Buck, who grew up in China as the daughter of American missionaries, wrote the book while living in China and drew on her firsthand observation of Chinese village life. The sympathetic depiction of the farmer Wang Lung and his wife, O-lan, helped prepare Americans of the 1930s to consider the Chinese as allies in the upcoming war with Japan. In a strategic way, the book also developed empathy as a foil to the previous decades of disgraceful racism and political

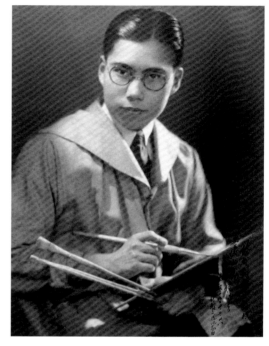

retribution against Chinese Americans, beginning with the Chinese Exclusion Act of 1882. The sculptures received wide praise during the time that they were originally exhibited, and most felt the series was a positive step in race relations. It also laid the groundwork for other well-intentioned visual art exhibitions exploring similar subjects, such as Steichen's photo-essay *The Family of Man*, created for the Museum of Modern Art, New York, in 1955.

In the early years after Chao-Chen Yang's arrival in Chicago, he had not developed an artistic aesthetic yet. Although he already possessed skills developed in China, he was determined to expand his technique and develop a visual language to express his individual point of view. When Jean reunited with him in Chicago in 1934 after a year of separation, he now had additional incentive to succeed both financially and artistically. He and Jean welcomed a baby boy on October 3, 1936, named Edgar Ping Lee. Jean recognized her husband's special talents as an artist and as a human being. She would provide essential support for him throughout their life together.

While at the Art Institute, Yang created accomplished paintings and drawings in the Western tradition, concentrating on typical subjects of the time such as urban scenes, still life, and portraiture (figs. 20–25). However, when he began producing photographs in earnest, he seems to have found his métier. The initial photographic works that he created in Chicago appear to have been influenced by the same motivational aspects as Hoffman's racial "types." Perhaps he felt his photographic work could better illuminate his intentions within the framework of his activities with the Chinese Consulate. The drawings that he created in the mid-1930s are evidence of his artistic abilities and growing sensitivity (figs. 26–28).

fig. 20. "Paintbrush in hand, canvas in front, calling to mind my love's encouragement and expectation! To my love: Yours. Written on February 28th, 1934. One year anniversary since our parting."
Courtesy of Edgar Yang

fig. 21. "To my beloved Qīzi (wife), whom I parted for a year, Your Chen. Written on February 28th, 1934. One year anniversary of us being apart."
Courtesy of Edgar Yang

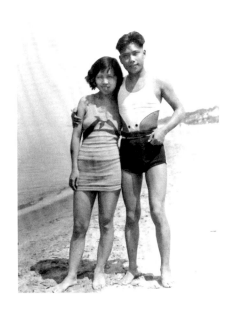

fig. 22. Jean and Chao-Chen at the
beach, Chicago, 1934
Courtesy of Edgar Yang

fig. 23. Chao-Chen Yang (1909–1969)
Untitled (Chicago city scene), circa
1934
Oil on board
24 × 20 in.

fig. 24. Chao-Chen Yang (1909–1969)
Untitled (Still life, basket, and rubber
plant), circa 1934
Oil on board (recto)
20 × 23 ¾ in.

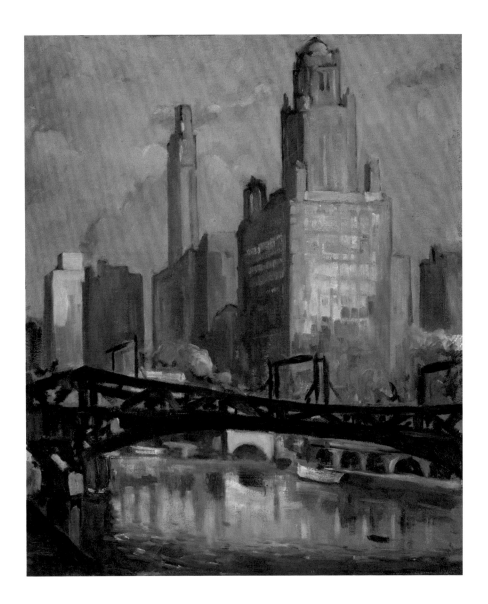

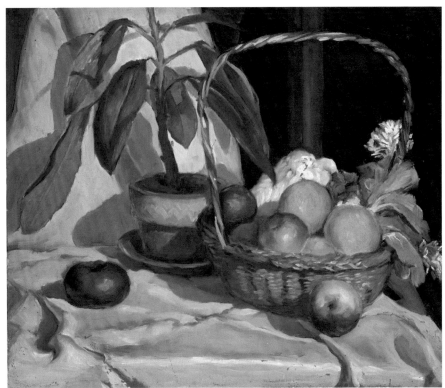

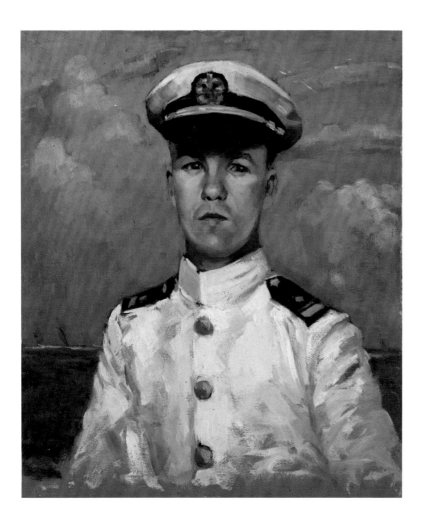

fig. 25. Chao-Chen Yang (1909–1969)
Untitled (Navy ensign), circa 1934
Oil on board (verso)
23¾ × 20 in.

Using a Reflex-Korelle 2½ × 2½ camera, he initially created photographs of "types," with the same models who posed for his drawings. This is the case for one of his most famous works, *Rickshaman* (figs. 29, 30), as well as *Korean Peasant* (fig. 31), both using the same model and neglecting the fact that the Korean peasant is not wearing Korean clothing. *Rickshaman* was likely inspired by the Hoffman sculpture but infused with Yang's own personal experience as a Chinese citizen. His rickshaw man expresses empathy and dignity, by depicting an actual human being as opposed to the detached generalization that the Hoffman sculpture provided. Another motivating factor might have been the famous Chinese novel *Rickshaw Boy* by the distinguished Chinese writer Lao Sheh (Shu Qingchun, 1899–1966), first published in 1937, coinciding with the probable date of Yang's photograph.

His other early masterwork, *Chief Owasippe*, was also an attempt to represent an archetype, since the subject was a legend and not an actual person. Yang was very involved with the Boy Scouts at this time and participated in organizing events and activities, such as the 1937 National Jamboree, where he was a delegate representing the Boy Scouts of China (fig. 32). The group met in Washington, DC, and returned to Chicago after its completion. Camp Owasippe, in west-central Michigan, was the primary Scout camp for the Chicago area during that time. In a recent inquiry posed to Mike Mieszczak, historian for Camp Owasippe, he explained that "Mr. Yang would have either traveled to camp by train or steamboat and arrived at Whitehall, then hiked a short distance to the camp. There is usually an opening campfire, which welcomes scouts to camp. During that campfire, the legend of Owasippe is told and acted out by camp staff members dressed as Potawatomi tribesmen. This is sort of a

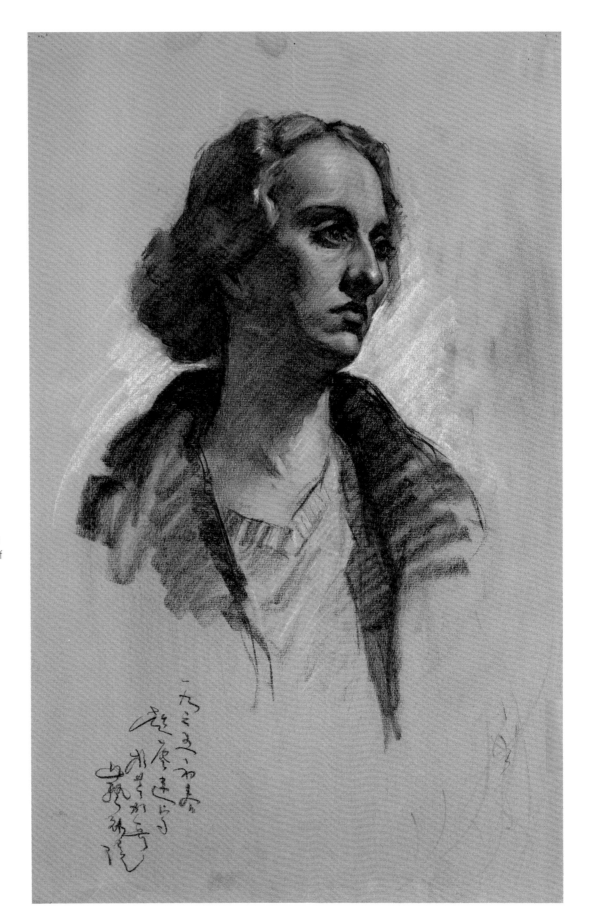

fig. 26. "Early Spring in 1935, sketch by Chao-Chen at the Art Institute of Chicago."
Charcoal and chalk on paper
20 × 12 ¾ in.

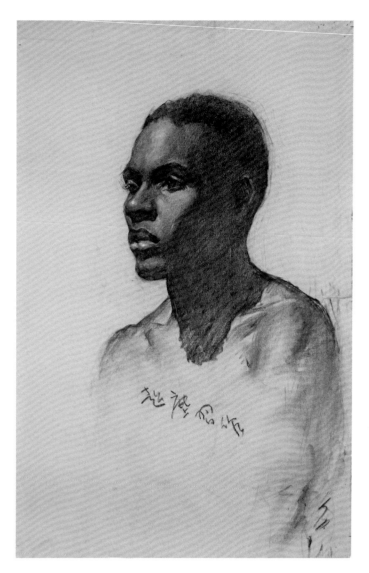

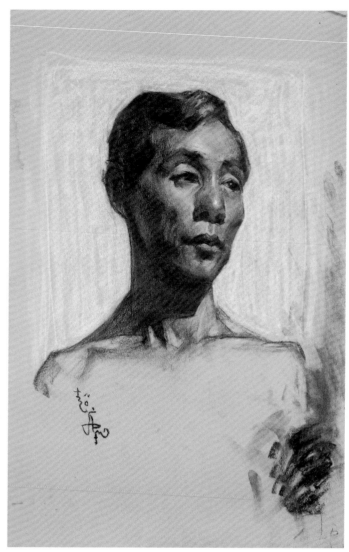

fig. 27. "Drawing practice by Chao-Chen," circa 1935
Charcoal on paper
20 × 13 in.

fig. 28. Chao-Chen Yang (1909–1969)
Untitled, circa 1936
Charcoal and chalk
20 × 12 ½ in.
Translation: "Chao Chen"

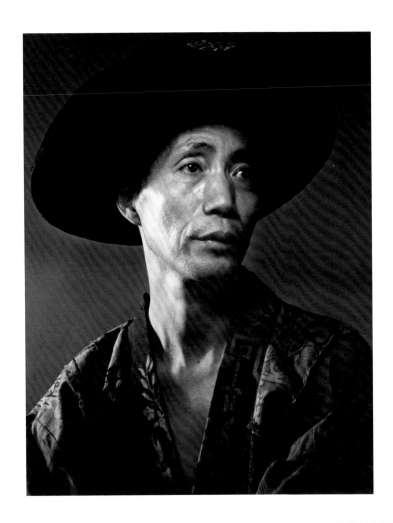

fig. 29. Chao-Chen Yang (1909–1969)
Rickshaman, circa 1937–38
Chlorobromide
13 ½ × 10 ½ in.

fig. 30. Verso of the mount for
Rickshaman, with affixed exhibition
labels
20 × 16 in.

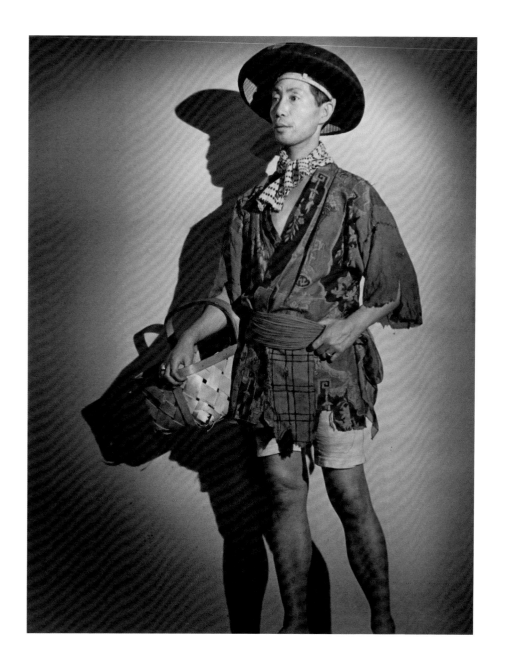

fig. 31. Chao-Chen Yang (1909–1969)
Korean Peasant, circa 1937–38
Chlorobromide
13 ⅜ × 10 ⅜ in.

fig. 32. Boy Scout group as part of
the National Jamboree, 1937
Yang is standing behind the Scout
master.
Courtesy of Edgar Yang

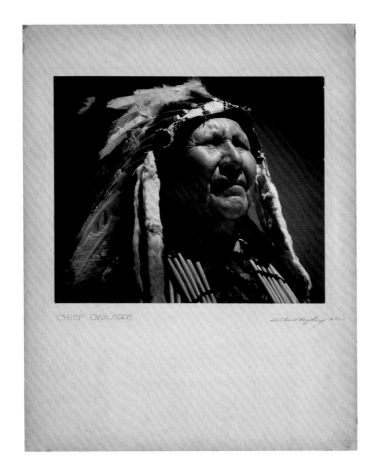

sacred camp ritual that continues to this day. Yang's picture is probably one of the camp staff dressed as Chief Owasippe for the reenactment" (figs. 33, 34).[10] As Yang's artistic career was growing, his family situation in China became disheartening. His parents were placed in refugee camps after the Japanese attacked Shanghai in August 1937. A tremendous sense of guilt must have occupied his waking hours as he worried about the fate of his parents, siblings, and young daughter back home.

As he developed his photographic potential, he expanded his visual vocabulary by including street photography. As opposed to depicting a single figure posed in a studio with dramatic lighting, works such as *Watchful Waiting*, circa 1938, were captured on a busy street in Chicago using natural lighting and with a grittier urban aesthetic more contemporaneous with the realities of the economic depression. For this particular photograph, he uses a more abstract compositional structure, with the three businessmen shot from a lower observation point allowing for the distortion of their actual height and compressing them within the space to convey the crowded and impersonal interactions within a big city (fig. 35; see also p. 69).

In late 1938 or early 1939, Yang accepted an assignment to move to Seattle as chancellor of the Chinese Consulate under Kiang Yi Sang. It was his and Jean's intention to return to China after the assignment was completed. When they arrived, he found an extremely active group of artistic photographers, some possessing international reputations. The Seattle Photographic Society (SPS) had begun in 1933 as the offshoot of the highly successful Seattle Camera Club (SCC), which disbanded three years earlier. Many of these photographers were Issei, Japanese immigrants who had formed Seattle's first internationally known arts group,

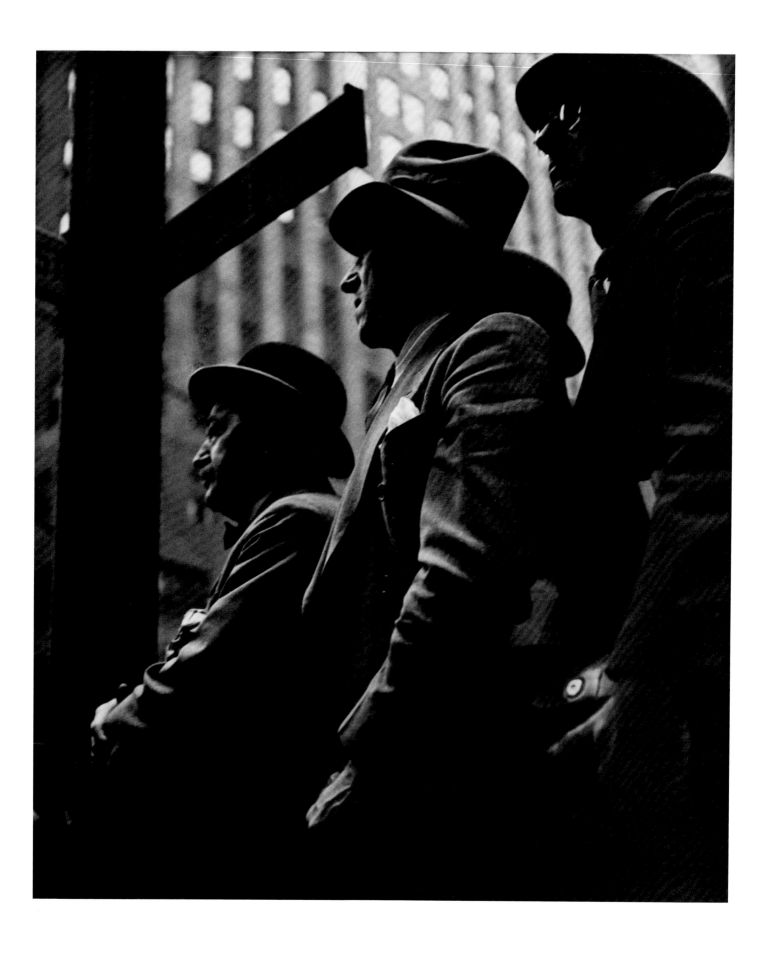

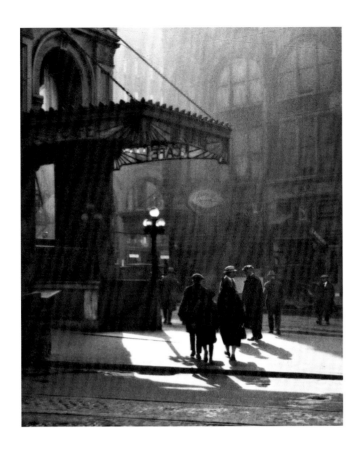

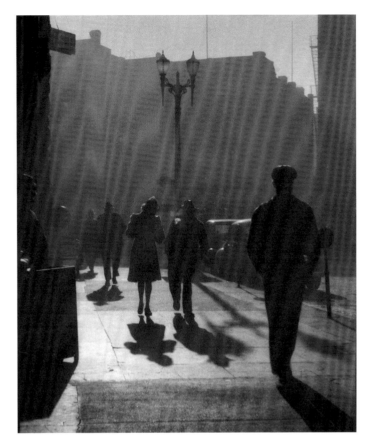

fig. 35. Chao-Chen Yang (1909–1969) *Watchful Waiting*, circa 1938, printed 1940
Chlorobromide
12 ⅛ × 10 ½ in.

fig. 36. Yukio Morinaga (1888–1968) *Morning*, circa 1924
Bromide print
11 ½ × 9 ½ in.
Private collection

fig. 37. Chao-Chen Yang (1909–1969) *Misty Morning*, circa 1939
Chlorobromide
12 ¾ × 10 ⅝ in.

ten years earlier. The SCC members had tremendous success during the 1920s, with seven members being among the top ten most exhibited photographers in North America by 1928. Although the Issei members of the SCC assisted in its formation, they never exhibited with the SPS. Seattle also had numerous extremely talented and recognized painters and print-makers during this period, but Yang was determined to explore the potential of photography. He was admitted to membership in the SPS on November 14, 1939.

Many of the Issei photographers lived and worked in Seattle's Nihonmachi (Japan town). One of the SCC's most successful and talented members was Yukio Morinaga (1888–1968), who lived just a few blocks away from where Yang had his office in the Smith Tower. Morinaga's emphasis on street photography and urban scenes would have appealed to Yang, whose *Watchful Waiting* photograph was created in the year before he arrived in Seattle. Morinaga's photograph *Morning*, circa 1924 (fig. 36), was obviously the inspiration for Yang's photograph titled *Misty Morning*, circa 1939 (fig. 37), suggesting that the two men knew each other. And perhaps Yang remembered Morinaga from the 1933 photography exhibition at the Chicago World's Fair six years earlier, where two of Morinaga's photographs were included. Yang's photograph was taken in almost the exact same spot as Morinaga's, at the intersection of First Avenue, James Street, and Yesler Way, just a block away from Yang's office in the Smith Tower. Morinaga was also a superb technician with many years of experience and expertise, a vital connection for a young photographer trying to advance in the same field. Several of Yang's earlier works are directly inspired by Morinaga's photographs of the previous decade.[11]

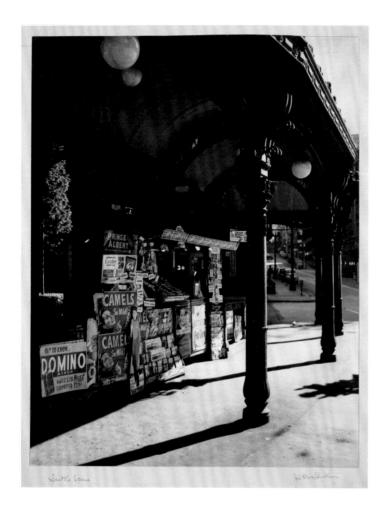

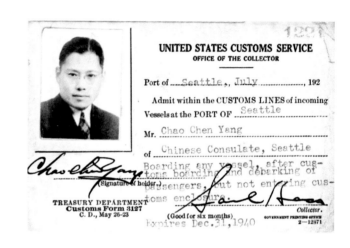

When the SCC held its last exhibition in 1930, most of the Issei members, many of them hobbyists, returned to their regular jobs to make a living to survive the dismal economic depression. The more important members like Morinaga, Frank Asakichi Kunishige, Ella McBride, and Virna Haffer all continued to work in one capacity or another in the darkroom. Kyo Koike (1878–1947), the leading figurehead of the SCC, was able to weather the economic depression as a practicing medical doctor with an adequate income. This allowed him to continue participating in salon competitions and to maintain his stature within the international pictorialist movement into the 1930s.[12] One active member of the SPS from the beginning was John D. "Jack" McLauchlan Jr. (1909–1999), who was a friend of Koike, Morinaga, and Kunishige. It is likely that Yang met these artists through McLauchlan, who also produced works in the Nihonmachi area for some of his street photography (fig. 38). In a parental situation similar to Yang's, McLauchlan was the son of an Episcopal minister who instilled generosity and public service in his son and namesake. The Very Reverend John D. McLauchlan (1881–1946) was the first dean of St. Mark's Episcopal Cathedral in Seattle and a noted public figure.

Yang and Jack McLauchlan became close friends, both producing photography while maintaining their professional careers, McLauchlan as an attorney and Yang in the consulate. McLauchlan was connected to most of the major photographic figures in the Northwest. He was a friend of the photographer Darius Kinsey (1869–1945) and posed for him when he worked as a lumberman in his youth. In 1934 and 1935, McLauchlan was the director of transient camps at Carnation and Cedar Falls, Washington, assisting unemployed and

fig. 38. John D. McLauchlan Jr.
(1909–1999)
Seattle Scene, circa 1940
Gelatin silver
20 × 16 in.
Private collection

fig. 39. Chao-Chen Yang's
United States Customs Service
identification, 1940
Courtesy of Edgar Yang

fig. 40. Chao-Chen Yang (1909–1969)
Apprehension, circa 1938–40
Chlorobromide
16 ½ × 13 ¼ in.

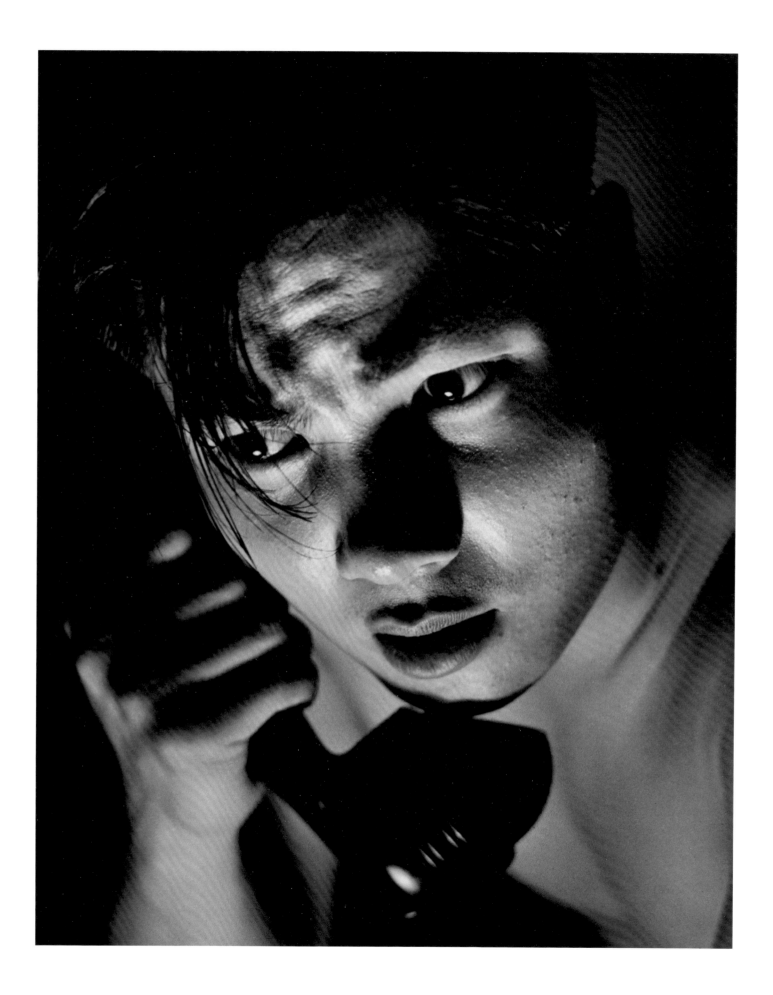

homeless men during this critical period. He was also a close friend of photographer Imogen Cunningham (who affectionately called him "JackMac"), and he literally saved the photographic output of Myra Albert Wiggins (1869–1956) when she was living alone and suffering from memory loss.[13]

In 1940, Yang started to increase his production and his pursuit of acceptance into salon exhibitions, despite his hectic schedule with the consulate (fig. 39). In the SPS January 1940 exhibition, his print *In Contemplation* won first place and the Popular Print Award, voted for by the public, while his *Steel and Smoke* (see p. 80) won third place. A third print, his *Watchful Waiting,* was also included in the exhibition. He became a fellow in the SPS later that year. Branching out to other prestigious national competitions, he was included in the Seventh International Salon of Photography, sponsored by the Pictorial Photographers of America, at the American Museum of Natural History in New York City, and his print *Chief Owasippe* was reproduced in the *New York Times.*[14] This was followed by his acceptance into Marshall Field's Fourth International Salon in Chicago. Yang was included in his first international exhibition when *Chief Owasippe* and *Rickshaman* were shown in the First International Vancouver Salon of Pictorial Photography at the Vancouver Art Gallery in British Columbia, Canada. The exhibition was sponsored by the Vancouver Photographic Society (affiliated with the Royal Photographic Society of Great Britain), and *Chief Owasippe* was one of only five works illustrated in the catalogue.

Over the next few years, in a rapid burst of creative production, Yang would create most of the works for which he became known. One of his well-known prints, *Apprehension* (fig. 40), was first exhibited with the SPS, in October 1941, and won the third-place prize. Four months later, his print *Young Chinese Guerrilla* (fig. 41) won second place in the SPS February print competition. These two prints, anomalies in his body of work, have now become iconic images for their implied political content. Unfortunately, he never publicly explained or gave any details about the meaning behind these two particular images. The identity of the models remains a mystery. It is possible that both young men were actors associated with the Seattle Repertory Playhouse, founded by his friends Burton and Florence Bean James, who were known in the region for their progressive social and political beliefs. Burton James also modeled for Yang, and he and his wife were interested in Chinese literature and theater. *Apprehension* gives the appearance of a still from a film noire movie, with a young man receiving an urgent phone call perhaps summoning him to a secret meeting or maneuver. *Young Chinese Guerrilla* is even more perplexing, calling to mind a Hollywood glamour shot in the manner of George Hurrell (1904–1992) or Ruth Harriet Louise (1903–1940). It is presumed that Yang at the very least was trying to pay tribute to the young men who were heroically involved in the resistance toward Japanese military aggression since the beginning of the Second Sino-Japanese War.

Yang was now included among the prominent group of Chinese artists who were leading figures in Seattle's art scene. They included Fay Chong (Chen Huizhuan, 1912–1973), Andrew Chinn (Chen Jingnian, 1915–1996) (fig. 42–44), and Henry Huan Lin (1915–1989) (fig. 45). Chong and Chinn co-founded the Chinese Art Club in Seattle in 1933; the club took a break during the war years and resumed in 1946. Lin became a leading ceramic artist in Seattle and an instructor at the University of Washington, until leaving in 1957 to begin a distinguished career at Ohio University. Chong had a joint exhibit with Yang in March 1944 at the Seattle Public Library.

fig. 41. Chao-Chen Yang (1909–1969) *Young Chinese Guerrilla,* circa 1938–40 Chlorobromide 16 × 12 ¾ in.

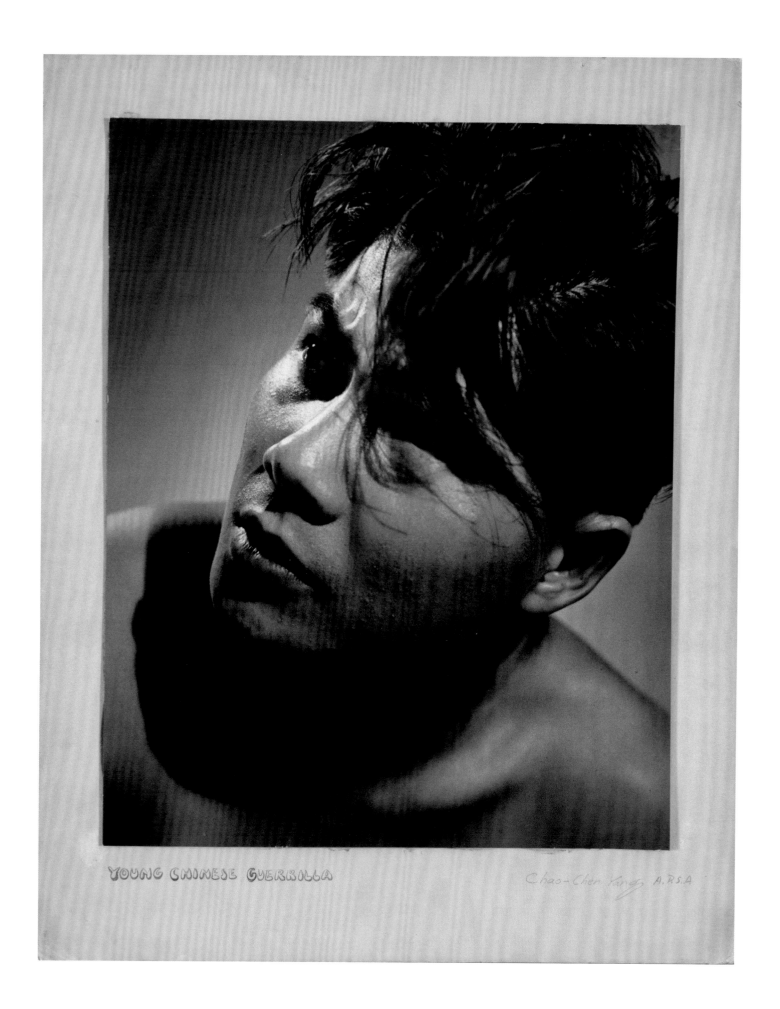

YOUNG CHINESE GUERRILLA Chao-Chen Yang, A.R.S.A

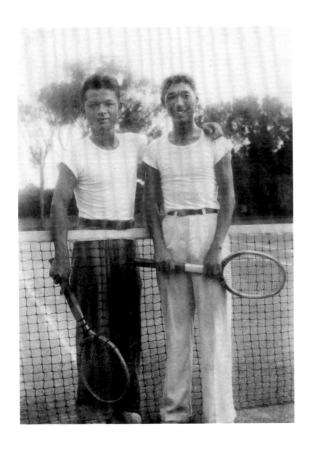

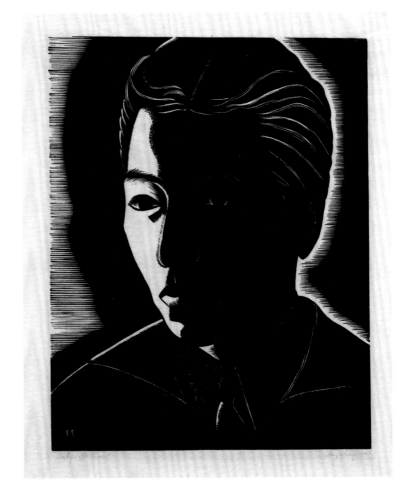

fig. 42. Andrew Chinn and Fay
Chong, circa 1935
Courtesy of Dennis Chinn

fig. 43. Fay Chong (1912–1973)
Self-Portrait, 1941
Linocut
10 × 8 in.
Private collection

By now, Yang had achieved an exalted position in the Seattle art and cultural commu-
nity. He was a distinguished artist, lauded by his peers, and was accorded such deference
that he was usually addressed as "Mr. Yang," even by those who knew and worked with him.
However, growing wartime tensions were beginning to evidence suspicion of his physical
appearance. In an article published in the SPS newsletter of March 1941, titled "Yang in a
Jam," the author pointed out, albeit in a comical manner: "Peter Anderson and C. C. Yang
had a slight brush with the law the other day, when they endeavored to photograph a certain
yard locomotive, wheezing in its ancient splendor in the yard of a local industrial plant. They
were apprehended in this act, by an energetic watchman not overburdened with excess 'I.Q.,'
who detained them and bellowed for the constabulary. When the authorities arrived, 'our
heroes' were promptly released with apologies."

A few months later, Yang, accompanied by McLauchlan, SPS president Ray Pollard, and
two other officers of the organization, was pulled over by the police on the way to Vancouver,
British Columbia, to view the second international exhibition of pictorial photography at
the Vancouver Art Gallery. Someone had spotted the men taking photographs and reported
to the police that "a Jap spy and two Krauts" were suspiciously taking pictures. Luckily, with
Yang's credentials presented and McLauchlan being a practicing attorney, they were detained
only a short time and released. McLauchlan memorialized the group in a photograph show-
ing the men after the incident (fig. 46).[15]

By this time, Yang and McLauchlan were experimenting with techniques derived from
the publications of William Mortensen (1897–1965) (figs. 47, 48). Mortensen, one of the most

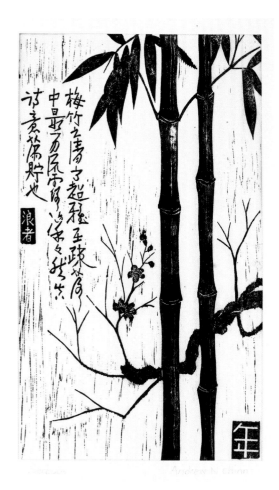

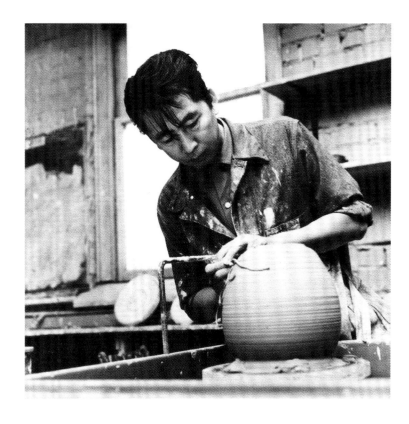

fig. 44. Andrew Chinn (1915–1996)
Bamboos, circa 1935
Linocut
11 ½ × 6 ⅞ in.
Dennis Chinn, Promised gift to
Cascadia Art Museum
Translation: "The nobleness and
elegance of plum flowers and
bamboos are most easily revealed in
sparseness."

fig. 45. Henry Huan Lin, undated
Courtesy of School of Art + Design,
Ohio University, Athens, OH

fig. 46. John D. McLauchlan Jr.
(1909–1999)
Members of the Seattle
Photographic Society on an outing
to Vancouver, BC, 1941
From left: Ray Pollard, unidentified,
Chao-Chen Yang, unidentified.
Scanned from the original negative.

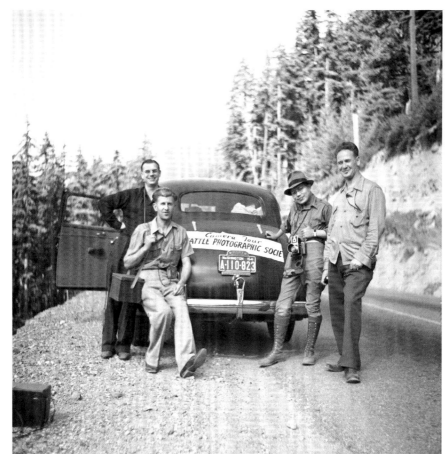

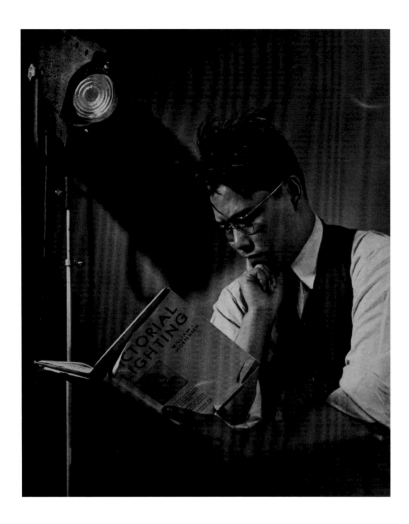

fig. 47. John D. McLauchlan Jr.
(1909–1999)
Portrait of Chao-Chen Yang reading
William Mortensen's book *Pictorial
Lighting*, circa 1941
Gelatin silver
13 ⅞ × 10 ⅞ in.

interesting American photographers of the period, had an eye for the bizarre and dramatic. Drawing from his technical books, Yang and McLauchlan portrayed themselves in both comical and serious situations (figs. 49–53). Both men continued to exhibit with the SPS, with Yang emphasizing mysterious dark imagery, such as his unusual self-portrait titled *Solitude* (figs. 54–56). These works of the early 1940s may have been the result of learning that his young daughter in China had died when she was unable to receive proper medication. He and Jean were devastated at the realization that they would never be able to reunite with their first child.

Yang used his remaining family as models during this time and was professionally and socially involved with members of the SPS (figs. 57–59). One close friend whom he shared with McLauchlan was Richard H. Anderson (1908–1970). Anderson was a talented photographer who had moved to Seattle in 1925 after completing an apprenticeship with the Bachrach Studios in Cincinnati. He formed a close bond with Ella McBride and eventually became her business partner. The McBride and Anderson Studio was one of the leading portrait studios in Seattle for decades, until it closed in the 1960s. Anderson's and Yang's poignant studies of an apparently deaf black woman were highly influenced by McBride and illustrate the collaborative activities between SPS members (figs. 60, 61).

In February 1942, President Franklin D. Roosevelt signed Executive Order 9066, allowing for the forced removal of people of Japanese ancestry on the West Coast into isolated incarceration camps against their will. Soon, all of Yang's Issei friends lost their livelihoods and were incarcerated for several years. Even former SCC member Soichi Sunami, who started his career in Seattle and later moved to New York City, burned all of his works

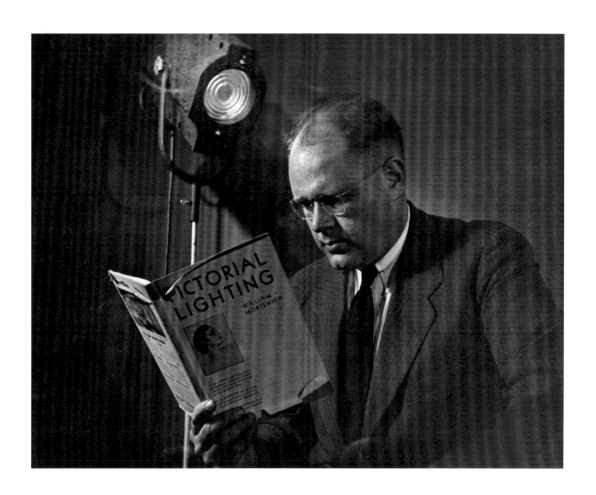

fig. 48. Chao-Chen Yang (1909–1969)
Portrait of John D. McLauchlan Jr.
reading William Mortensen's book
Pictorial Lighting, circa 1941
Gelatin silver
10 ⅞ × 14 in.
Private collection

fig. 49. Chao-Chen Yang (1909–1969)
Self-Portrait, circa 1941
Gelatin silver
13 ⅛ × 10 ¾ in.

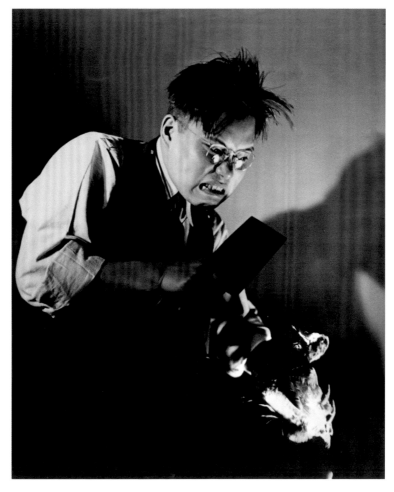

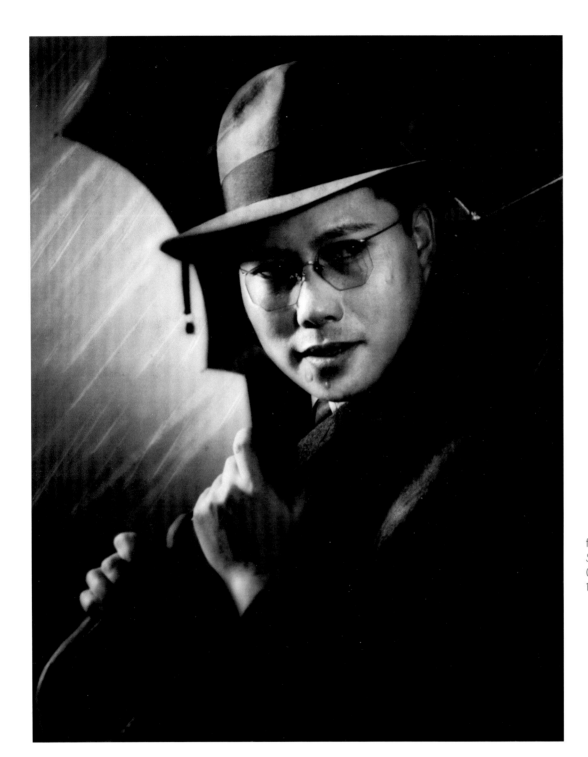

fig. 50. Chao-Chen Yang (1909–1969)
Self-Portrait, circa 1941
Chlorobromide
13 ½ × 10 ½ in.

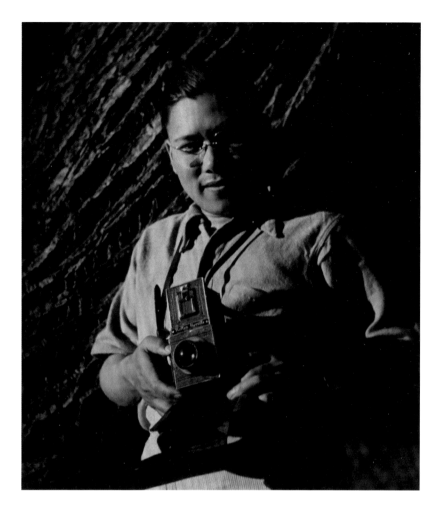

fig. 51. John D. McLauchlan Jr. (1909–1999)
Portrait of Chao-Chen Yang, circa 1940
Chlorobromide
12 × 10 ½ in.

Inscribed to Yang (verso), "John D. McLauchlan, Attorney at Law and professional ambulance chaser by appointment."

fig. 52. John D. McLauchlan Jr. (1909–1999)
Photograph inscribed "Yang in search of Chastity" (recto), circa 1940

fig. 53. Jean and Chao-Chen at a party with Jack McLauchlan (*far left*) and his wife, artist Ebba Rapp, and artist Jacob Elshin (*foreground*), circa 1943.
Martin-Zambito archive, Seattle, WA

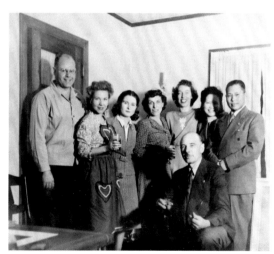

41

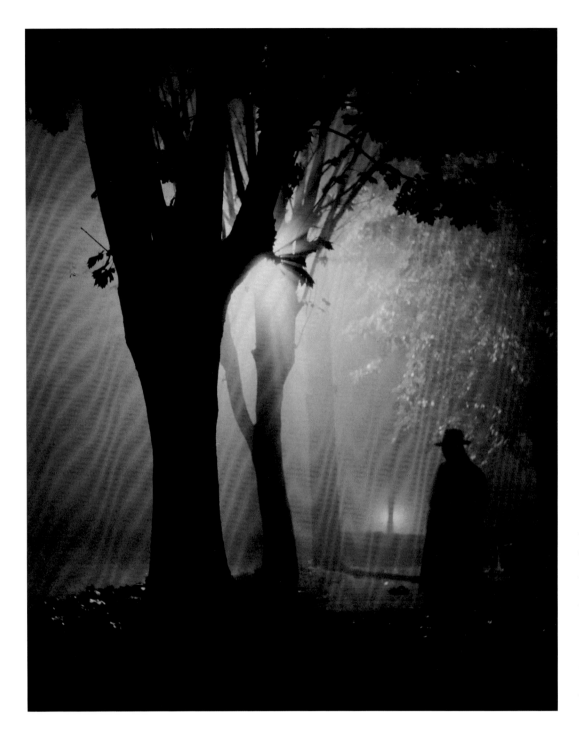

fig. 54. Chao-Chen Yang (1909–1969)
Solitude, circa 1940
Gelatin silver
16 × 13 ½ in.

Yang took this photograph a few blocks from his home. "I was returning home at midnight when I saw the possibilities of the spot, which is quite commonplace by daylight. . . . I set up my camera and then looked around for someone to serve as a figure in the scene. It was late and there was no one in sight so I opened the shutter and posed myself in front of the camera for three minutes, then ran and closed the shutter" ("Chao-Chen Yang . . . Artist from the Orient," by Jack Wright, *Camera* 67, no. 8 [August 1945]: 18).

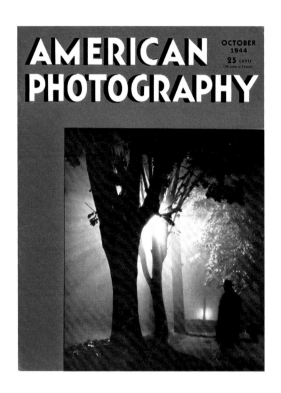

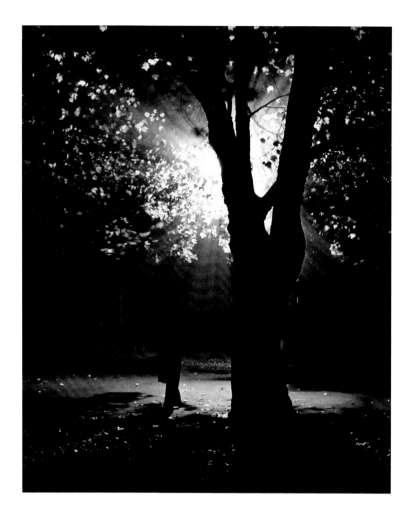

fig. 55. *American Photography* magazine, October 1944
Courtesy of Edgar Yang

fig. 56. Chao-Chen Yang (1909–1969) Untitled (variation on *Solitude*), circa 1940
Gelatin silver
16 ⅝ × 13 ¾ in.

fig. 57. Members of the Seattle Photographic Society with friends and family members, 1940. Chao-Chen and Jean are pictured fifth and sixth from the right. Noted Seattle portrait photographer Yuen Lui is pictured second from the left.
Courtesy of Edgar Yang

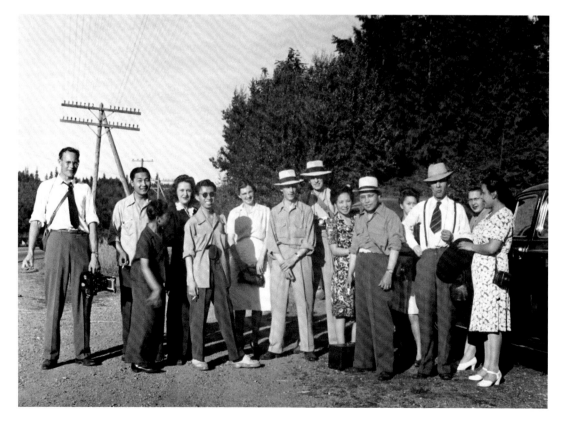

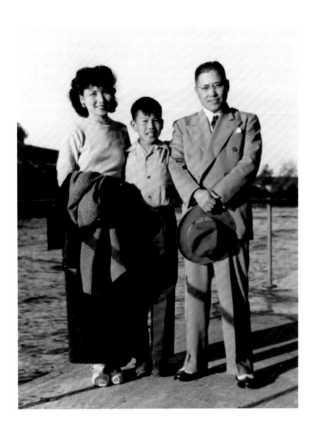

depicting female nudes as a safeguard from any type of governmental accusations during World War II. Because he was on the East Coast, Sunami was never forced into an incarceration camp, allowing him to maintain his position as chief photographer for the Museum of Modern Art, although the museum never included Sunami's artistic photographs in any of its exhibitions and still has not as of this writing.[16]

Perhaps the timing of the incarcerations explains why Yang never created any other works that could be misconstrued as foreign propaganda. Yang's son, Edgar, explained that during the war years, he and family and friends wore buttons and badges identifying them as "Chinese" to avoid harassment and violence for being mistaken as Japanese.

On August 14, 1944, Roosevelt appointed Yang deputy consul of China in Seattle. The Yangs and McLauchlan, through Yang's consulate position, began assisting Chinese immigrants. Edgar recalled:

> In those days, people would visit us in that tiny apartment that my folks used to refer to as a "telephone booth." Most of the visitors were illiterate Chinese seamen whom my father encountered through his work in the consulate. Since they could neither read nor write and suffered from having poor English, they relied on my father for help. Both he and my mother were exceedingly generous and would not only help them but invited them over to the house for home-cooked meals. Furthermore, he would give them money if they needed it, and to my knowledge,

fig. 58. Jean, Edgar, and Chao-Chen, undated
Courtesy of Edgar Yang

fig. 59. Chao-Chen Yang (1909–1969)
Portrait of Jean, 1941
Gelatin silver
6 ⅜ × 4 ½ in.

fig. 60. Richard H. Anderson
(1908–1970)
Untitled, 1942
Chlorobromide
13 ½ × 10 ¾ in.

The model is posed with the *Seattle Daily Times* newspaper dated Tuesday, September 1, 1942. She appears to be pointing at a map detailing the advances of Allied forces against Nazi Germany.

fig. 61. Chao-Chen Yang (1909–1969)
Untitled, 1942
Chlorobromide
17 ½ × 15 ¼ in.

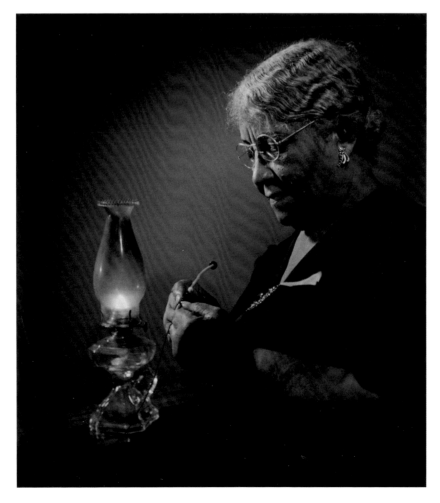

they always paid him back. Those folks never forgot my parents' kindness, and their friendship persisted until the day they died.

Jean would eventually become one of the founders of the Seattle Chinese Women's Club and the Seattle Chinese School.[17]

McLauchlan undoubtedly assisted his friend in these legal matters. In 1946, he was one of two attorneys who represented a Chinese crew that had commandeered a Japanese ship at the beginning of the war, arriving in Seattle in February 1942, just two months after Pearl Harbor was attacked. They imprisoned two Japanese officers and improvised navigation charts to steer the ship, the *Wilhelmina*, to Seattle. The US government confiscated and used the ship under the War Shipping Administration, naming it the *Coventry*. The crew filed a lien for $27,000 against the ship for wages, which McLauchlan and fellow attorney Jack McWalter successfully obtained, as well as procuring the return of the ship to the crew before most returned to China. The second mate of the ship, Liu Dah-pun, received a bachelor of science degree in meteorology from the University of Washington and a graduate degree from the California Technical Institute. This was the first "prize of war" case in the World War II–era United States.[18] In 1985, McLauchlan received the Washington State Bar Association's Award of Honor and Merit for his longtime work in immigration law.

It was not until 1950, well after the war ended, that Yang made a color Flexichrome print of *Apprehension*. He had been interested in the possibilities of color photography for several years. In 1939, the photographer Ivan Dmitri published the seminal book *Color in Photography*, followed the next year by *Kodachrome and How to Use It*. It is highly likely that Yang was influenced by these instructional books, as they coincide with the timing of his first experiments in color photography. The same is likely true for his colleague in Tacoma, Virna Haffer, who was also active in both the SCC and the SPS. Her studio was the first in Washington State to offer color photography for portraiture, as a 1941 newspaper advertisement attests (fig. 62).

Haffer explored the technique mostly for portraiture but later joined Yang in using it for artistic expression, especially color photograms. Soon, the SPS encouraged members to submit Kodachrome slides for competition. The SPS became so well known in the region that it was the subject of a regular radio show titled *Your Camera Club* on Radio KEVR. In 1947, broadcasting pioneer Dorothy Bullitt purchased KEVR and changed the call letters to KING (for King County, Washington).

In 1943, Yang became an associate of the Photographic Society of America and claimed to have had seventy-six of his photographs accepted in twenty-four international salons. He won several "solid gold" trophies with the SPS as well (fig. 63). He was involved in establishing the First International Salon of Photography held at the Seattle Art Museum, June 9–July 19, 1943. He served as judge and was also represented in the exhibition as vice president of the organization. That year, he traveled to San Francisco to greet Madame Chiang Kai-shek in a personal appearance and began a two-year position as a faculty member at the University of Washington, teaching Chinese in the Army Specialized Training Program.[19]

The first mention of a color print in Yang's exhibition history occurred in February 1943, when he won first place in the SPS's competition for a print titled *Rhythm in Color*. No example of this print has survived. In a 1944 letter from Canadian photographer Johan Helders

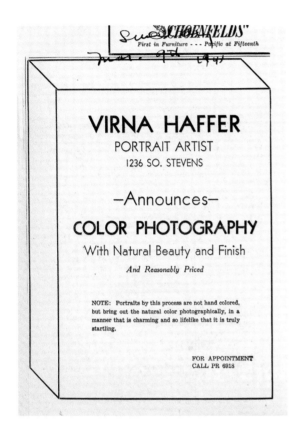

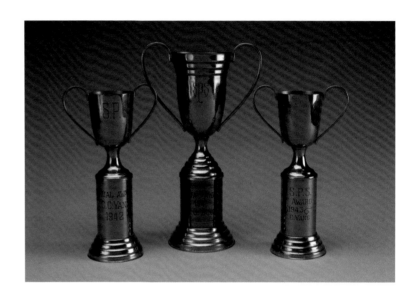

fig. 62. Advertisement for Virna Haffer's portrait studio in the *Tacoma News Tribune*, March 9, 1941. Courtesy of the Estate of Virna Haffer

fig. 63. Trophies awarded to Chao-Chen Yang from the Seattle Photographic Society. *From left*: 1942, 1941, 1943. Courtesy of Edgar Yang

(1888–1956) to Yang, he expressed his admiration for one of his color prints: "Your metal tone print 'Still-life in Color' is a marvel; the results you obtained with whatever chemical and procedure you used are wonderful" (fig. 64).[20] In 1945, now deputy consul, Yang stated: "I am experimenting with a process for making color prints from black-and-white negatives and ordinary papers, by the reaction of certain metallic salts upon the silver deposit. The method was first found by accident but now I can control it sufficiently to produce almost any desired combination of colors. It takes between 20 minutes and two hours to turn out a 14 by 17 print. However, the process is yet to be perfected and I do not think it would be wise to discuss it further."[21] In one of his final acts as deputy counsel, Yang participated in a conference in San Francisco, where he assisted in forming the Chinese version of the United Nations Charter.[22]

In 1946, with a growing professional reputation, Yang traveled to Los Angeles to see if his talents might be utilized in the film industry. He was described in a 1946 article in the *Valley Times* as being on the set of the film *The Bachelor and the Bobby-Soxer*, starring Cary Grant, Myrna Loy, and Shirley Temple: "C. C. Yang, a courteous young Chinese who is being groomed by Shanghai movie interests as a director, stood by taking notes on technical matters, as he has done throughout the production."[23] He followed this project by apprenticing with the noted cinematographer James Wong Howe, who was filming *Mr. Blandings Builds His Dream House*, which also co-starred Grant and Loy. Jean and Edgar visited him during his time in California and were allowed to observe the filming behind the scenes. Howe, a

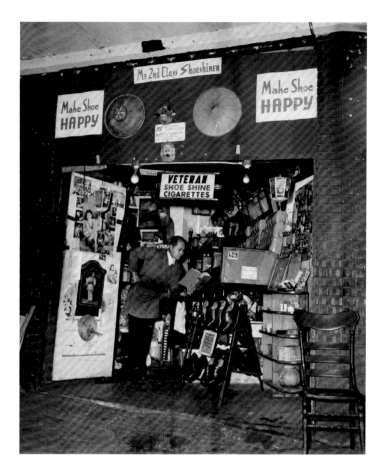

brilliant cinematographer, likely felt a kinship with Yang, as he grew up in Washington State as a Chinese immigrant.

When Yang returned from Hollywood, he ended his career in the consulate to concentrate solely on photography and the SPS. One of the more talented members, Austin W. Seth (1915–2006), produced a photograph titled *Skidroad Scholar* around this time (fig. 65). This ironic postwar image depicts an Asian American shoeshine operator surrounded by insulting, obsequious signage that conveys his subservient role in American society. Seth, a Seattle police chief by day, placed the model front and center in a non-subservient pose and holding a book, which indicates his striving to elevate himself to a higher position in society. This figure could easily relate to the stories of immigrants like Goon Dip who, from poor and humble beginnings, had tremendous success. Seth was ahead of his time in depicting the plight of Seattle's homeless and indigent population in a series of extraordinary photographs that he created while walking his beat.

In April 1947, with funds provided by the G.I. Bill after the war, Yang became director of the Northwest Institute of Photography and assisted in providing skills to returning military personnel to help them reintegrate back into society and make a living (fig. 66). He was sensitive to their issues, since he himself was a war veteran of the Chinese army. With Jean taking care of family and business obligations, he was able to sustain a living over the next few years. In 1949, Yang became a member of the Royal Photographic Society of Great Britain and concurrently joined its pictorial group.[24] In September of that year, he began teaching a class

fig. 64. Chao-Chen Yang (1909–1969)
Untitled, circa 1943–44
Metal-Chrome print (deteriorated)
16 ¾ × 13½ in.

This is likely one of Yang's first attempts at color photography and might possibly be *Still Life in Color* mentioned in a 1944 letter from Johan Helders, who attempted to purchase or trade with Yang for the print.

fig. 65. Austin W. Seth (1915–2006)
Skidroad Scholar, circa 1947
Gelatin silver
20 × 16 in.
Courtesy of the Austin W. Seth family

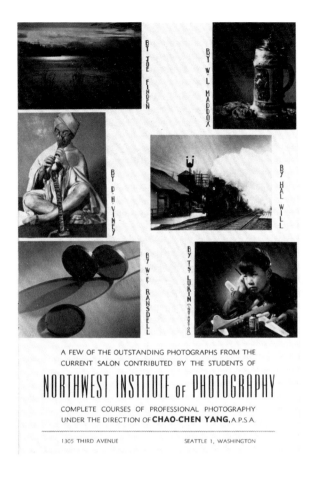

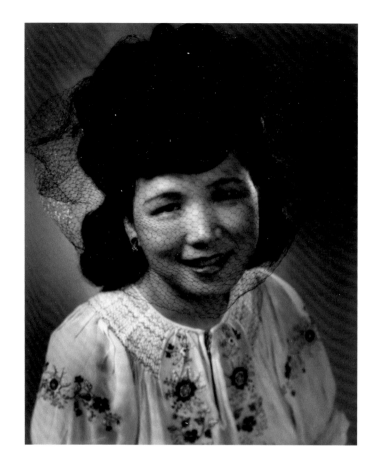

fig. 66. Advertising brochure for the Northwest Institute of Photography, 1947
Courtesy of Edgar Yang

fig. 67. Chao-Chen Yang (1909–1969)
Jean, 1948
Chlorobromide
16 ¾ × 13 ⅞ in.

at the institute in color photography, which could greatly benefit a career in advertising. The progress that he made through hard work during the previous ten years in Seattle appeared to be endangered when, just one month later, on October 1, the Communist leader Mao Tse-tung declared the creation of the People's Republic of China. Within a few months, the Seattle Chinese Consulate ceased activity. Instead of letting this political defeat slow him down, Yang proceeded with a renewed fervor. It cannot be overemphasized the important role Jean played in her husband's artistic and financial success. Her belief in him and her unwavering love allowed him to continue his passion (fig. 67).

At the institute, Yang taught several color methods, such as Dye Transfer, Ektacolor, Printon, and Flexichrome. An unusual process being promoted by Kodak, Flexichrome utilizes a method of taking a black-and-white print and hand painting it with layers of color (figs. 68, 69). Using his training as a painter, Yang beautifully rendered prints in this medium, compared to the overly saturated colors of some of the artistic and commercial uses of the process. In 1950, he created the only Flexichrome print of *Apprehension* (figs. 70–72).

By 1951, Yang's Northwest Institute of Photography closed when the funds provided by the G.I. Bill ceased. Never one to accept defeat, he briefly joined his friends Yuen Lui (1913–1974) and Que Chin (1911–1974) at their successful Cathay Studio, until opening his own commercial studio specializing in color photography. With his growing success in this field, Yang maintained his association with his friends in the SPS. He created color images for several covers of its annuals, including for 1953 and 1954 (figs. 73, 74).

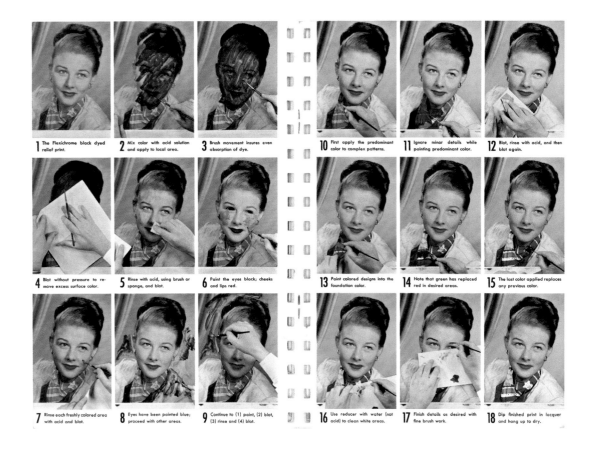

1 The Flexichrome black dyed relief print.

2 Mix color with acid solution and apply to local area.

3 Brush movement insures even absorption of dye.

4 Blot without pressure to remove excess surface color.

5 Rinse with acid, using brush or sponge, and blot.

6 Paint the eyes black; cheeks and lips red.

7 Rinse each freshly colored area with acid and blot.

8 Eyes have been painted blue; proceed with other areas.

9 Continue to (1) paint, (2) blot, (3) rinse and (4) blot.

10 First apply the predominant color to complex patterns.

11 Ignore minor details while painting predominant color.

12 Blot, rinse with acid, and then blot again.

13 Paint colored designs into the foundation color.

14 Note that green has replaced red in desired areas.

15 The last color applied replaces any previous color.

16 Use reducer with water (not acid) to clean white areas.

17 Finish details as desired with fine brush work.

18 Dip finished print in lacquer and hang up to dry.

fig. 68. Kodak Flexichrome Process instructional booklet, 1950
Martin-Zambito archive, Seattle, WA

fig. 69. Higgins Inks set used by Chao-Chen Yang.
Courtesy of Edgar Yang

fig. 70. Chao-Chen Yang (1909–1969)
Apprehension, circa 1949–50
Flexichrome print
15 ¾ × 12 ½ in.

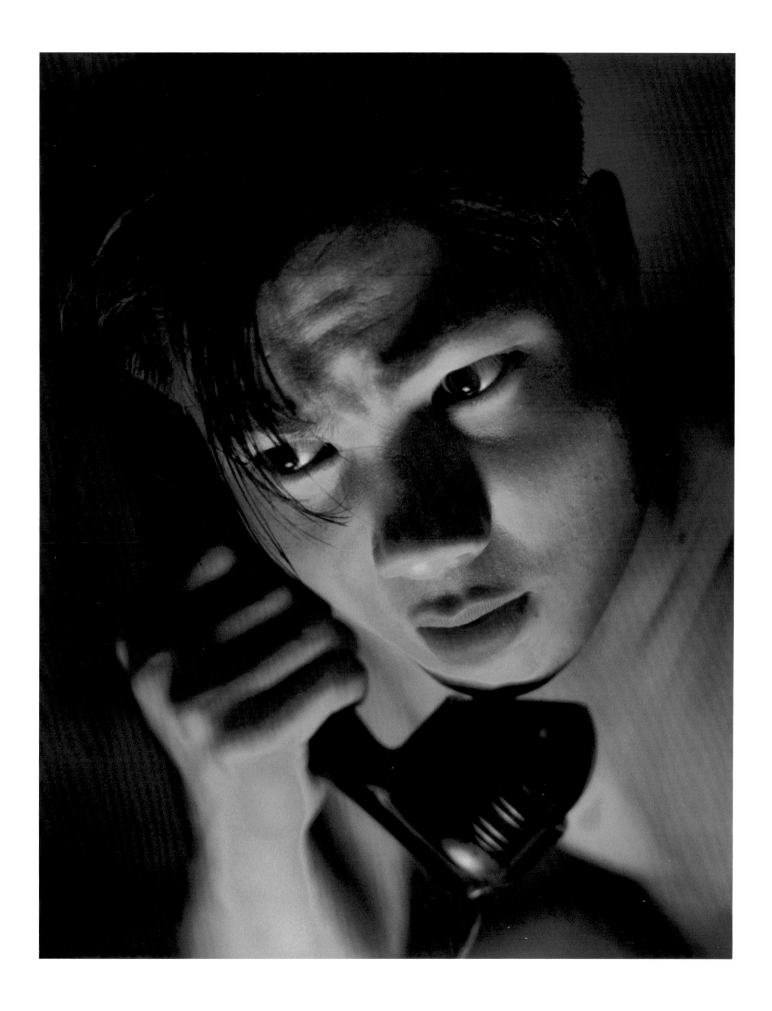

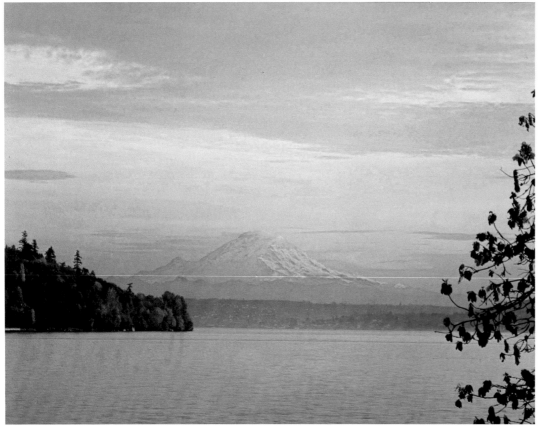

fig. 71. Chao-Chen Yang (1909–1969)
Good Earth
Flexichrome print, circa 1949–50
13 ¾ × 16 ⅞ in.

fig. 72. Chao-Chen Yang (1909–1969)
Mt. Rainier, circa 1949–50
Flexichrome print
12 ⅜ × 16 in.

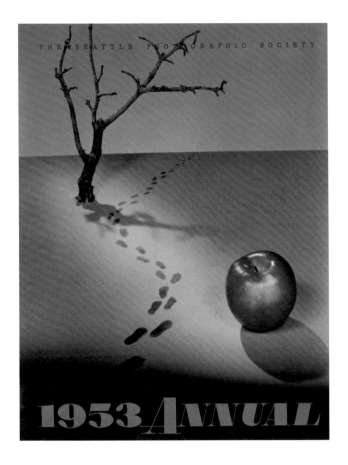

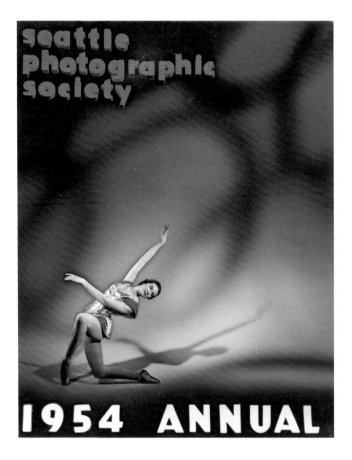

He and Jean remained active in the region's Chinese organizations. They were members of the China Club of Seattle, which in February 1953 adopted a resolution calling for national and international relief and resettlement programs for 1.25 million Chinese refugees in Hong Kong in need of assistance. Yang was vice president at the time and worked diligently in the campaign.[25]

Setting the standard for color photography in the Northwest, Yang began working within the region's advertising community. He began an association with the most powerful local corporation, the Boeing Airplane Company, which commissioned him to create special photographs of new and experimental aircraft as well as high-quality images for its international advertising (fig. 75).

He maintained his association with the SPS, gave lectures and workshops, and served on the jury for several competitions (fig. 76). Because of his extremely busy schedule, he closed his color studio and joined forces with Tall's Camera Supply in Seattle in August 1955, as director of the firm's color processing plant (fig. 77). This assured him a steady income, and within a few months he became a US citizen. Later that year, he fulfilled a lifelong desire to travel and work in Europe. For this yearlong journey, he created some of the most successful color works of his illustrious career. He photographed primarily in Paris and Rome, often wandering into the countryside of both cities to experience contrasting environments (fig. 78). When he returned, he received a master of photography certificate from the Photographers Association of America in July 1956. Over the next few years, he successfully

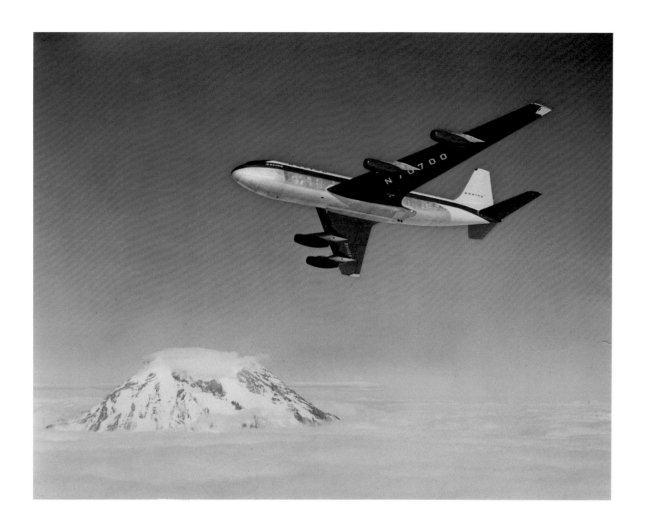

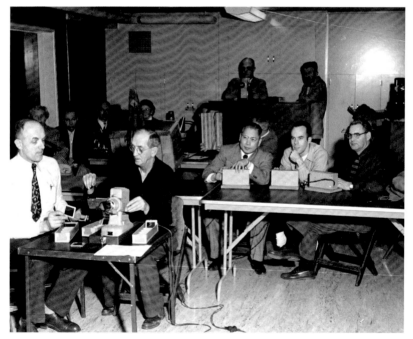

fig. 75. Chao-Chen Yang (1909–1969)
Boeing Dash 80 aircraft, 1954
Dye Transfer print
15 × 19 ¼ in.

The Boeing 367-80 was a prototype aircraft.

fig. 76. Judging a slide competition for the Seattle Photographic Society, 1954. Yang (*center*) is pictured with fellow judges Gervais Reed, curator of the Henry Art Gallery at the University of Washington, and Dale Goss, director of art education for Seattle Public Schools.
Courtesy of Edgar Yang

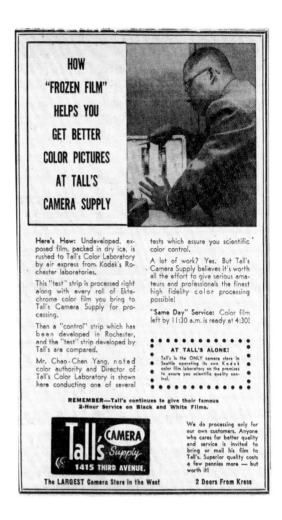

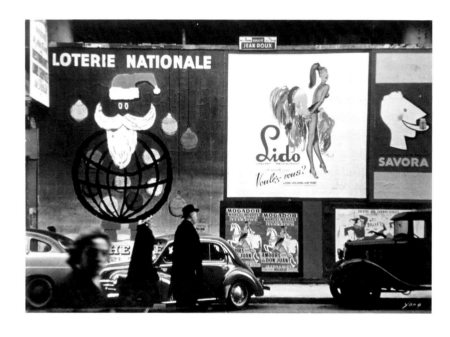

fig. 77. Advertisement for Tall's
Camera Supply, Seattle, 1958
Courtesy of Edgar Yang

fig. 78. Chao-Chen Yang (1909–1969)
Night in Paris Street, 1955–56
Dye Transfer print
13 ½ × 19 ⅜ in.

navigated his production between advertising and creative artistic photography. He spent four years as an instructor at the Winona School of Photography in Indiana, beginning in 1957, teaching advanced commercial and color photography courses (figs. 79, 80).

In 1958, Yang was included in a prestigious national Eastman Kodak traveling exhibition of outstanding color photography in the United States. As he was completing teaching at the Winona School, he began feeling exhausted and ill, sometimes collapsing during classes. For decades, he was used to living on three or four hours of sleep a night, but his energy was running out and he knew something was wrong. In 1963, he was diagnosed with advanced kidney disease and was given only months to live. With a determined spirit, he began dialysis treatment at the University of Washington and then at Swedish Hospital in Seattle. Yang used the opportunity to educate the public and bring awareness to kidney disease. He stated in the press that he was the oldest patient allowed to undergo dialysis, was the first Asian in Seattle to receive it, and took it as a sense of pride that he paid the astronomical medical bills out of his own pocket. Twice a week he underwent grueling fourteen-hour treatments but would not stop working. He received a tremendous amount of family support from Jean and Edgar, who, after a successful architectural profession in California, returned with his wife, Linda, to Seattle. The Seattle Advertising and Sales Club as well as the National Professional Photographers Association rallied around Yang and sought out dozens of members to donate blood to ensure that he had enough for the treatments. He stated that he "was delighted that Caucasian blood flows in his Oriental veins—a symbol of universal brotherhood." He even

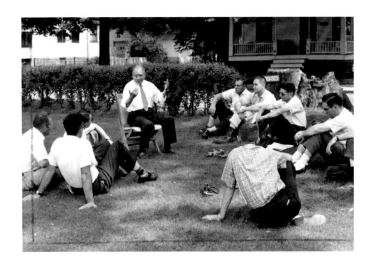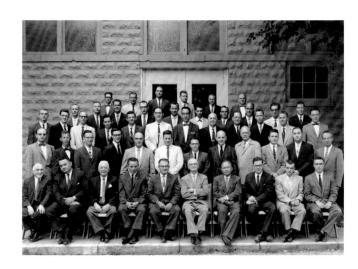

participated in promoting the Northwest Artificial Kidney Fund to assist other patients with the astronomical fees needed to participate in the treatments.[26]

Even with the exhausting treatments, Yang could not be idle. He merged his studio with two other advertising photographers to form the firm of Dudley, Hardin, and Yang in 1964 (figs. 81, 82).[27] Besides receiving a steady flow of commissions to stay busy, he also benefited from the company's medical insurance coverage. The treatments had caused his skin to turn dark brown, and he was sometimes mistaken for a black man. While at the firm, he elevated advertising photography to a fine art form. The extant prints from this period are imaginative and unique with superb design and color. This was during the time of Andy Warhol's depicting soup cans and other utilitarian products to emphasize the hidden power of design in familiar, everyday household products (fig. 83).

During the final time of his debilitating illness, he and Jean relied on their strong spiritual faith to guide them through each consecutive challenge. However, a series of large black-and-white charcoal drawings created during this time reveal the inner terror and uncertainty of his inevitable death (figs. 84–86).

His final photographs display a return to the solace of nature. Many of them are meditative observations of natural elements such as fire, earth, and water (fig. 87).

As he entered his last years, he made the best of an extraordinarily difficult and painful situation by staying involved in activities that were important to him and to which he dedicated his life. He and Jean were honored in Washington, DC, at a dinner sponsored

fig. 79. Yang teaching at the Winona School of Photography, Winona Lake, Indiana, 1960
Courtesy of Edgar Yang

fig. 80. Advanced Commercial Photography, class of 1960, Winona School of Photography, Winona Lake, Indiana, 1960. Yang is seated, bottom row, fourth from right.
Courtesy of Edgar Yang

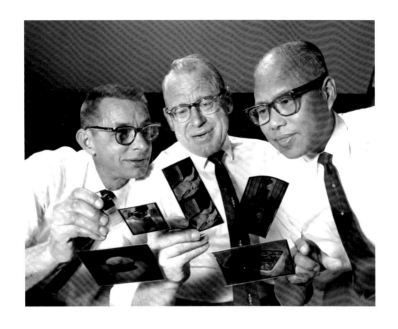

fig. 81. Roger Dudley, John Hardin,
and Chao-Chen Yang, 1964
Courtesy of Edgar Yang

fig. 82. Chao-Chen Yang (1909–1969)
Self-Portrait, circa 1964
Gelatin silver
10 × 8 in.
Courtesy of Edgar Yang

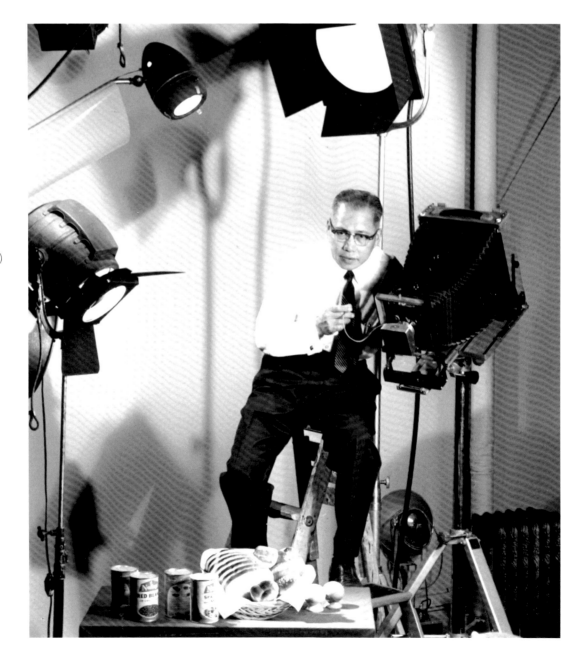

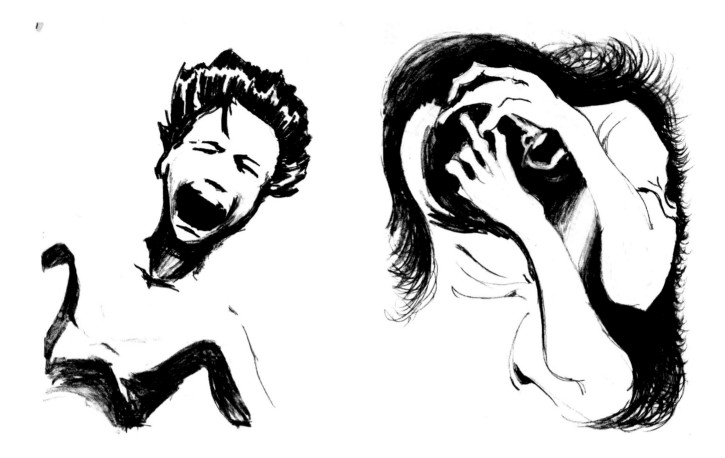

by Madame Chiang Kai-shek in September 1966. The following year found him still exhibiting his work and traveling to Rochester, New York, to accept the Progress Medal as a representative for Edward Steichen at a Photographic Society of America convention. Alfred Eisenstaedt was also awarded the society's International Understanding Through Photography Award at the same event.[28]

Yang ended his illustrious career as he began it thirty years prior, with his friends and colleagues in the SPS. He gave a final lecture for them on July 1, 1969, at St. Mark's Cathedral, with his friend Jack McLauchlan by his side in the very church where McLauchlan's father had served as deacon.

Chao-Chen Yang died on August 31, 1969. His beloved Jean remained active after his death with various clubs and travel to China to reconnect with family and friends. An intelligent and savvy investor, she had accumulated substantial funds after Chao-Chen's death and used some of her money to build a new school in the province in China where she had been born and raised.

Jean died on December 20, 2008, at the age of 102.

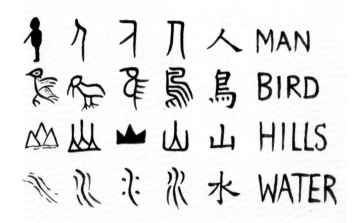

fig. 86. Chao-Chen Yang (1909–1969)
Untitled, circa 1965
Charcoal
24 × 19 in.

fig. 87. Chao-Chen Yang (1909–1969)
Man, Bird, Hills, Water, evolution of
Chinese logograms, date unknown
Ink on paper
23 × 27 ¾ in.

NOTES

1 David Takami, "Chinese Americans," HistoryLink.org, February 17, 1999, https://www.historylink.org/File/2060.

2 For further information, see David F. Martin, "Garden in the Darkroom," in *Captive Light: The Life and Photography of Ella E. McBride*, by Margaret E. Bullock and David F. Martin (Tacoma, WA: Tacoma Art Museum, distributed by University of Washington Press, Seattle, 2018).

3 For further information, see Tracey Strong and Helene Keyssar, *Right in Her Soul: The Life of Anna Louise Strong* (New York: Random House, 1983).

4 For further information, see Todd Rainsberger, *James Wong Howe, Cinematographer* (San Diego, CA: A. S. Barnes, 1981).

5 For further information, see Kathrine Beck, "Luke, Keye (1904–1991)," HistoryLink.org, May 4, 2020, https://www.historylink.org/File/21023.

6 David F. Martin and Nicolette Bromberg, *Shadows of a Fleeting World: Pictorial Photography and the Seattle Camera Club* (Seattle: University of Washington Press, 2011).

7 See David F. Martin, *The Lavender Palette: Gay Culture and the Art of Washington State* (Edmonds, WA: Cascadia Art Museum, distributed by University of Washington Press, Seattle, 2020); and Paul French, "Fabric of Society," *South China Morning Post*, February 12, 2023.

8 *The Horn Book Magazine*, October 19, 1950, 7.

9 From Yang's school records, provided by Bart Ryckbosch, archivist, Art Institute of Chicago.

10 Information derived from the Yang family's scrapbook; and Mike Mieszczak (historian for Camp Owasippe, Twin Lake, Michigan), email messages to author, March 18, 2023; June 16, 2023.

11 For further information about Morinaga and the history of the SCC, see Martin and Bromberg, *Shadows of a Fleeting World*.

12 Martin and Bromberg, *Shadows of a Fleeting World*.

13 Wiggins was a founding member of Women Painters of Washington (WPW) and the first internationally known photographer in the Northwest as a member of Alfred Stieglitz's Photo-Secession. In her later years, she nearly destroyed all of her own photographs due to oncoming dementia. McLauchlan was married to a prominent early WPW member,

Chao-Chen Yang's personal
exhibition poster, circa 1942
20 × 16 in.

Ebba Rapp, one of the most talented painters and sculptors in Seattle at the time. They looked after Wiggins in her small apartment nearby and safely stored her photographs.

14　Robert W. Brown, "For Amateur Photographers; 560 Prints Go on View: Pictorial Photographers of America Sponsor Seventh Exhibit," *New York Times*, March 10, 1940, ProQuest Historical Newspapers.

15　Yang's sanitized recollection of the incident was relayed in an article written for *The Camera* magazine in August 1945 (vol. 67, no. 8), "Chao-Chen Yang . . . Artist from the Orient," by Jack Wright (14–19). It was printed one month after World War II ended. The original typescript in the possession of Yang's estate credits the article to Willa Woods Hiltner of Pasadena, California. The magazine article gave the date of the incident as 1939, which is inaccurate since the car's license plate bears the date of 1941 and the Vancouver salon's first exhibition was in 1940. McLauchlan relayed the story to me personally in 1990 using the original ethnic slurs, which I have used in this essay, and presented me with the original negative of the photograph, which is still in my possession.

16　For further information, see David F. Martin, *Invocation of Beauty: The Life and Photography of Soichi Sunami* (Edmonds, WA: Cascadia Art Museum, distributed by University of Washington Press, Seattle, 2018).

17　Edgar Yang, oral history, in *Voices of the Second Wave: Chinese Americans in Seattle*, comp. Dori Jones Yang ([Newcastle, WA]: East West Insights, 2011), 360.

18　"Prize-of-War Ship Given Chinese Crew," *Seattle Daily Times*, March 13, 1946.

19　"Chao-Chen Yang, Diplomat, Photographer Is Honored," *Seattle Times*, November 5, 1943.

20　Johan Helders to Chao-Chen Yang, November 15, 1944, Chao-Chen Yang archive, in the possession of Edgar Yang.

21　Wright, "Chao-Chen Yang . . . Artist from the Orient," 84.

22　Ada Lou Wheeler, "A Philosophical Photographer," *Seattle Daily Times*, November 27, 1966.

23　*Valley Times*, September 17, 1946.

24　Michael Pritchard (director of programmes, Royal Photographic Society), email message to author, March 27, 2023.

25　*Seattle Daily Times*, February 20, 1953.

26　Don Duncan, "Machine Keeps 'Dead' Man Alive," *Seattle Daily Times*, November 25, 1964.

27　Yang's partners were Roger Dudley and John Hardin.

28　Jacob Deschin, "Photography: Advance Is Noted at P.S.A. Meeting," *New York Times*, August 13, 1967, ProQuest Historical Newspapers.

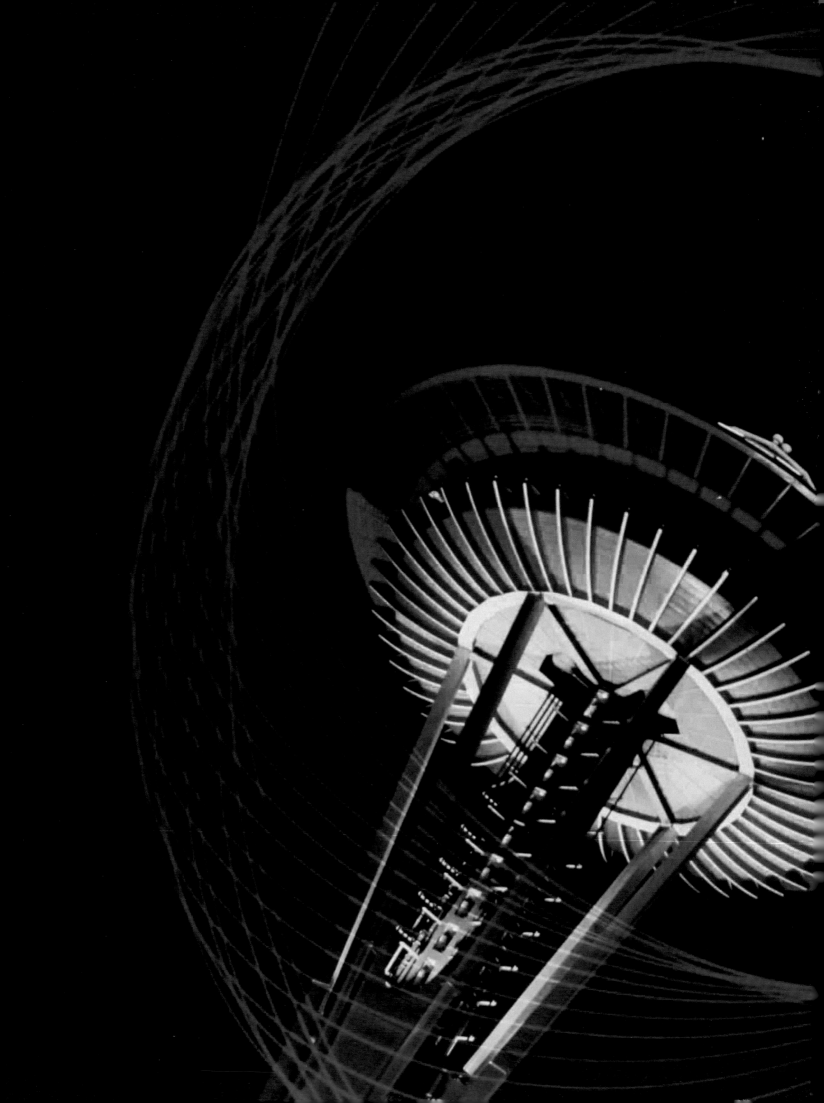

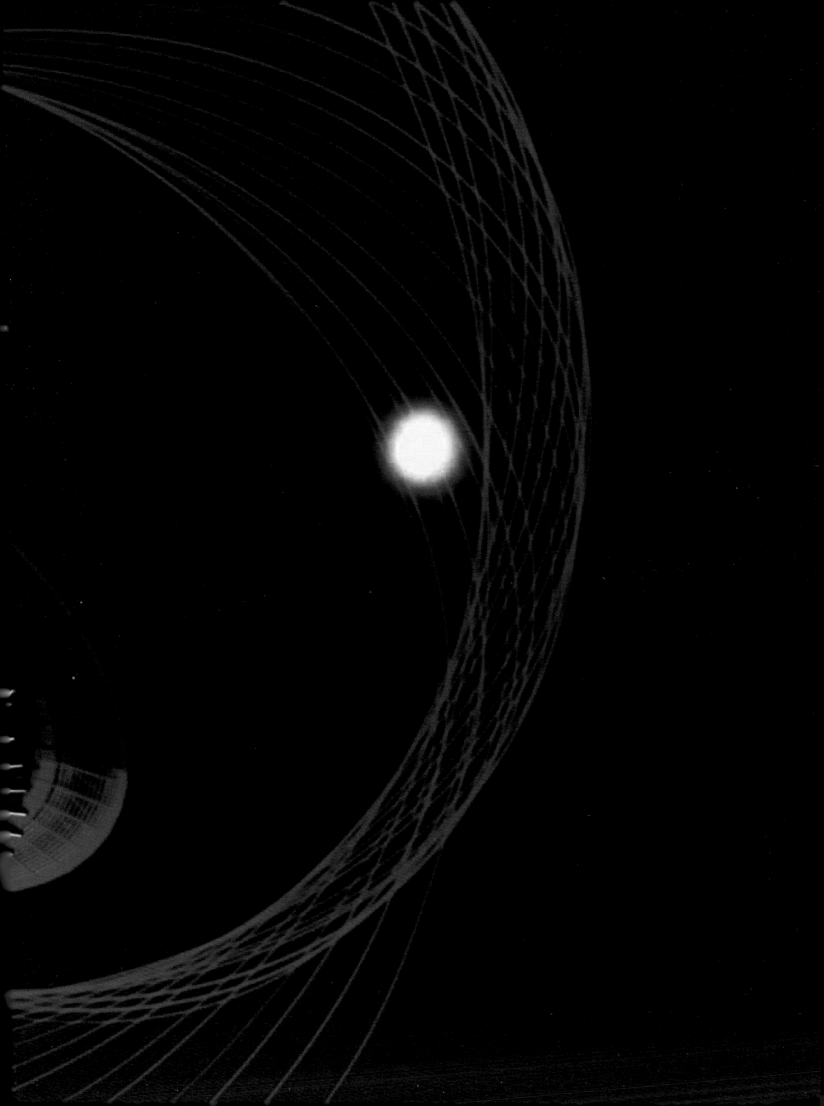

Chao-Chen Yang (1909–1969)
Untitled, circa 1937–39
Chlorobromide
11 ¼ × 9 ⅛ in.

C. C. Yang

Chao-Chen Yang (1909–1969)
Twilight, circa 1937–39
Chlorobromide
13 ¼ × 10 ¼ in.

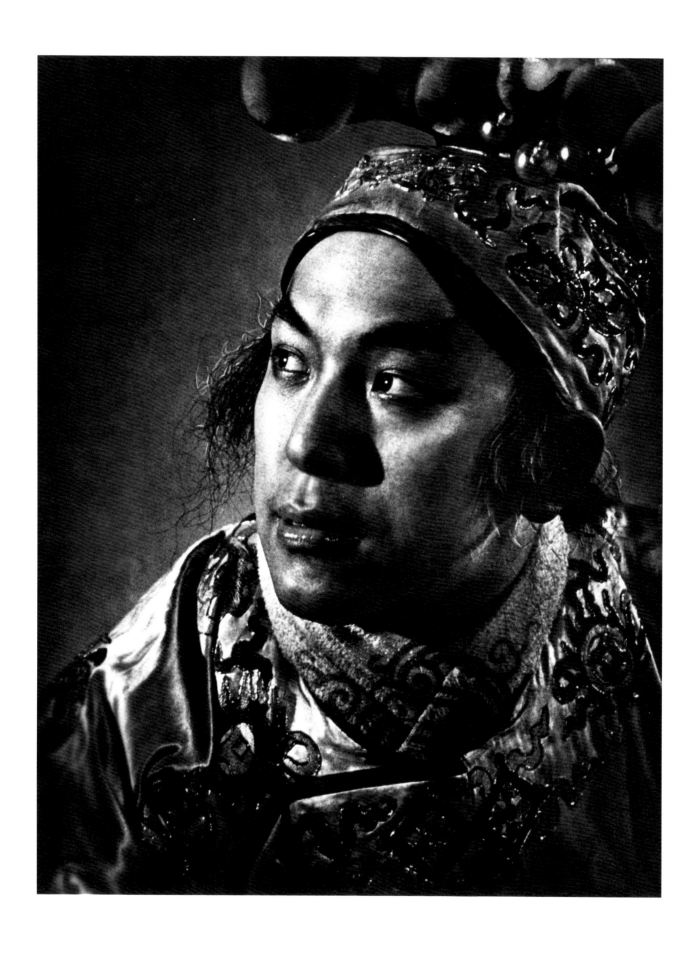

Chao-Chen Yang (1909–1969)
In Contemplation, 1937–39
Paper negative print
13 ¼ × 10 ¼ in.

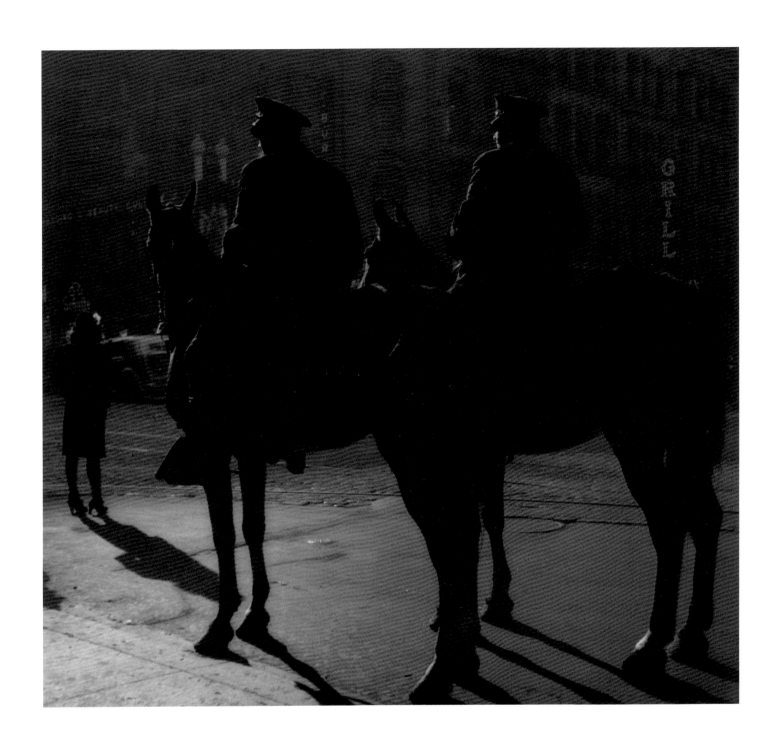

Chao-Chen Yang (1909–1969)
Untitled, circa 1938
Chlorobromide
10 ½ × 11 ⅝ in.

Chao-Chen Yang (1909–1969)
Untitled, circa 1938
Gelatin silver
2 ¼ × 2 in.

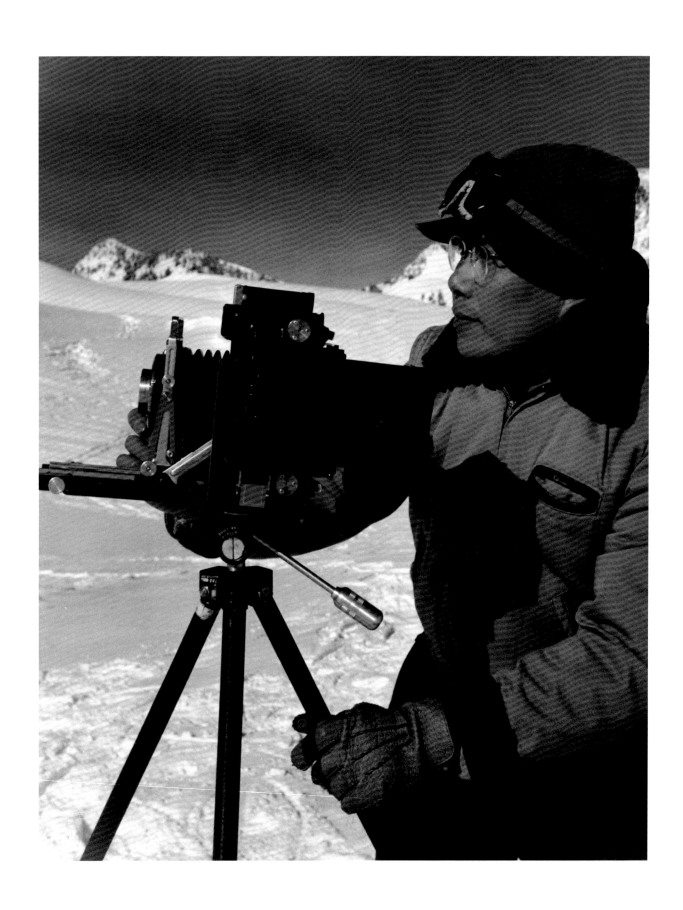

Chao-Chen Yang (1909–1969)
Self-Portrait, circa 1939
Gelatin silver
9 ½ × 7 ⅝ in.

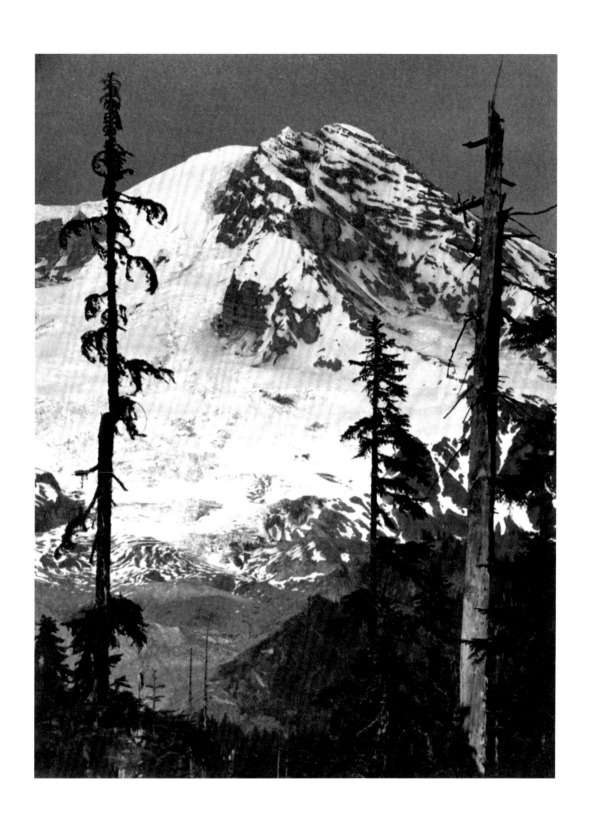

Chao-Chen Yang (1909–1969)
Mt. Rainier, circa 1939
Gelatin silver
6 ¼ × 4 ¾ in.

Chao-Chen Yang (1909–1969)
Untitled, circa 1939
Gelatin silver
4 ⅝ × 3 ⅝ in.

Chao-Chen Yang (1909–1969)
Untitled, circa 1939
Gelatin silver
4 ¾ × 3 ¾ in.

73

Chao-Chen Yang (1909–1969)
Untitled, circa 1939
Chlorobromide
7 ⅛ × 9 ½ in.

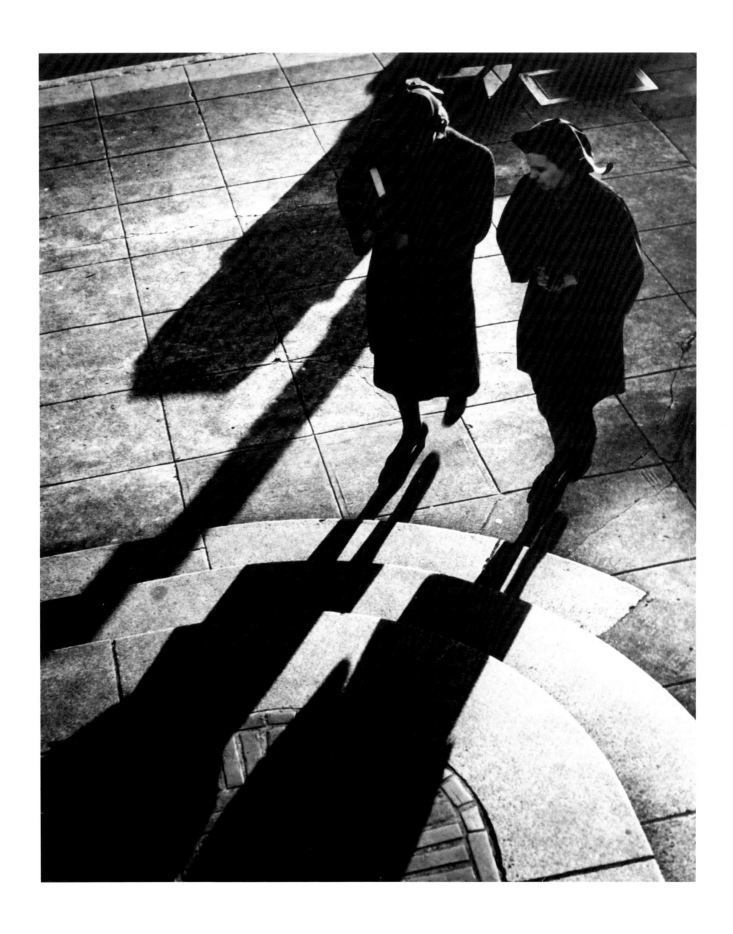

Chao-Chen Yang (1909–1969)
Untitled, circa 1939
Chlorobromide
11 ½ × 9 ½ in.

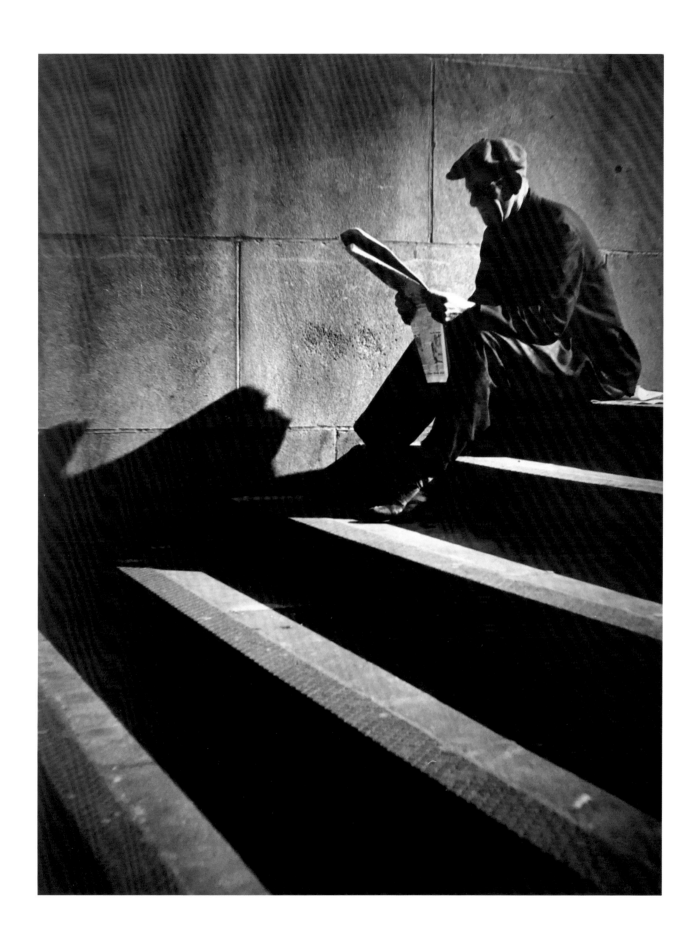

Chao-Chen Yang (1909–1969)
Leisure, circa 1939
Chlorobromide
13 ½ × 10 ½ in.

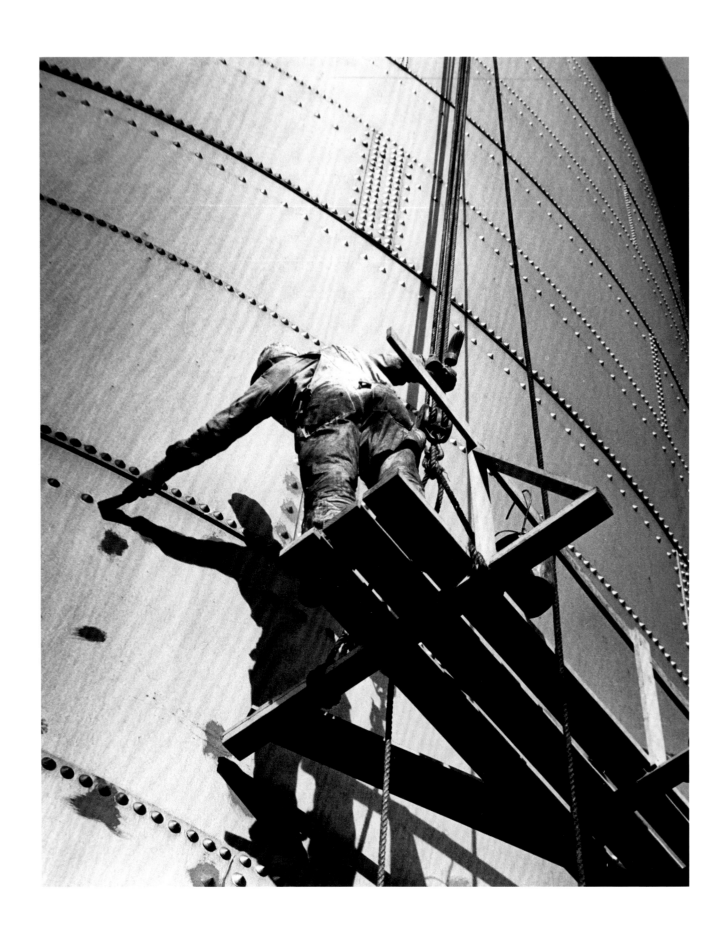

Chao-Chen Yang (1909–1969)
Spotting, 1939
Chlorobromide
11 ½ × 9 ¼ in.

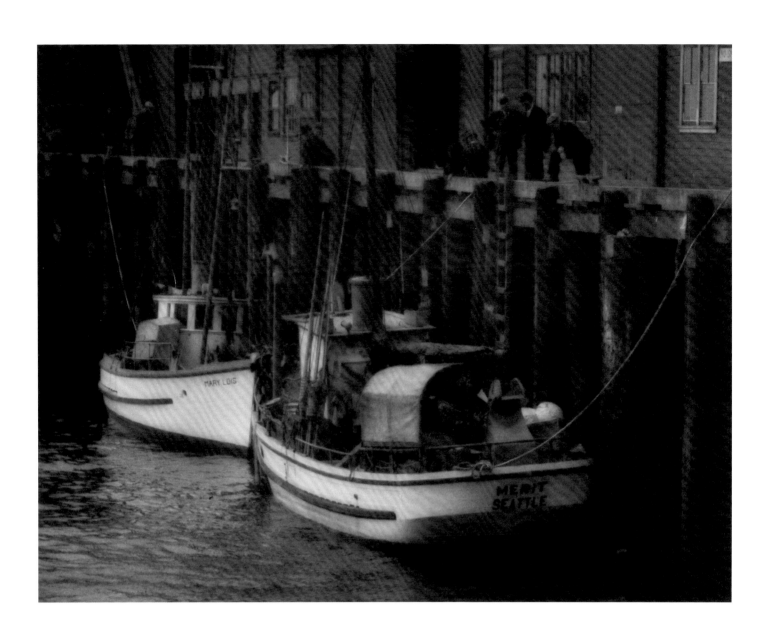

Chao-Chen Yang (1909–1969)
In Port, circa 1939
Chlorobromide
10 ¼ × 13 ⅛ in.

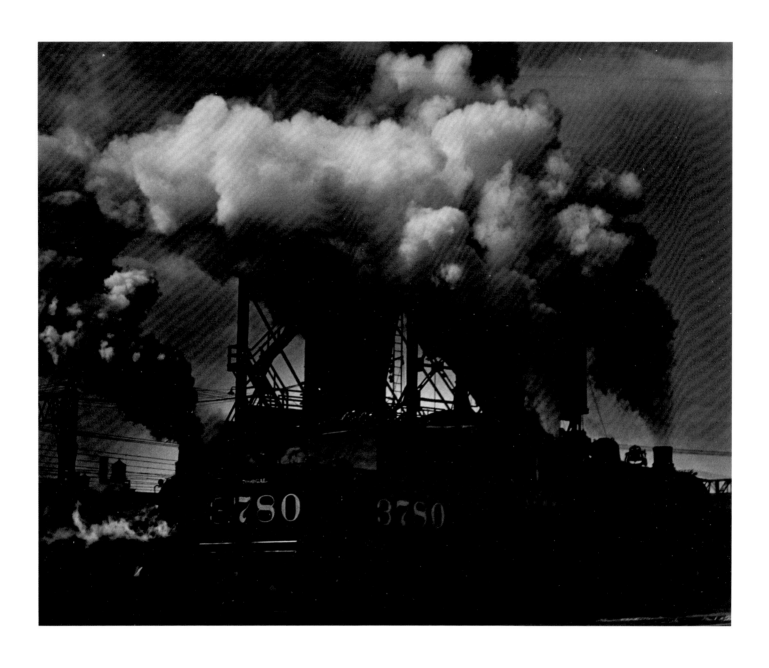

Chao-Chen Yang (1909–1969)
Steel and Smoke, 1939
Chlorobromide
10 ½ × 13 in.

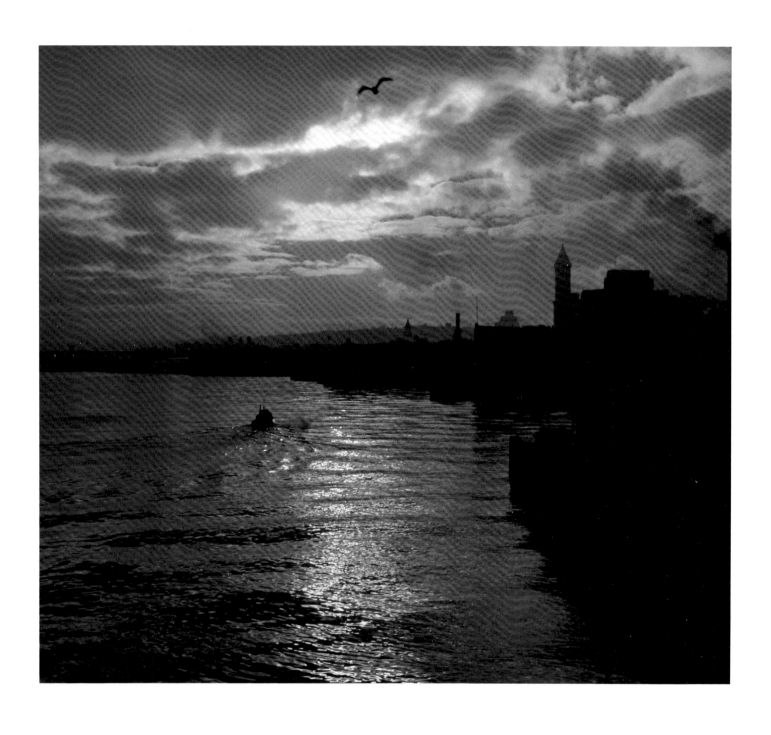

"Here is a study of the Seattle waterfront, called Twilight. Really, it was early morning and I was on a steamer just pulling out for Victoria (B.C.). See the small boat, the gull? I waited with my camera until they were in the correct place, asked myself 'how is composition?'" ("Chao-Chen Yang, Diplomat, Photographer Is Honored," *Seattle Times*, November 5, 1943).

Chao-Chen Yang (1909–1969)
Twilight, circa 1939
Chlorobromide
15 ⅝ × 17 ⅞ in.

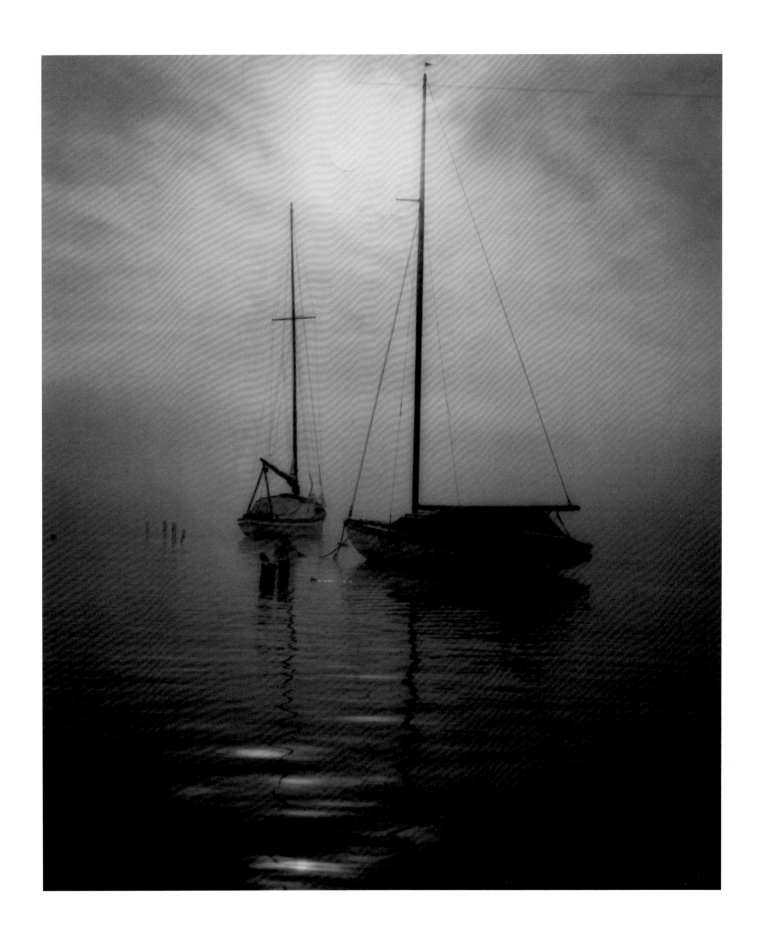

Chao-Chen Yang (1909–1969)
Mist, circa 1939
Composite print using two negatives
Chlorobromide
15 ¼ × 13 in.

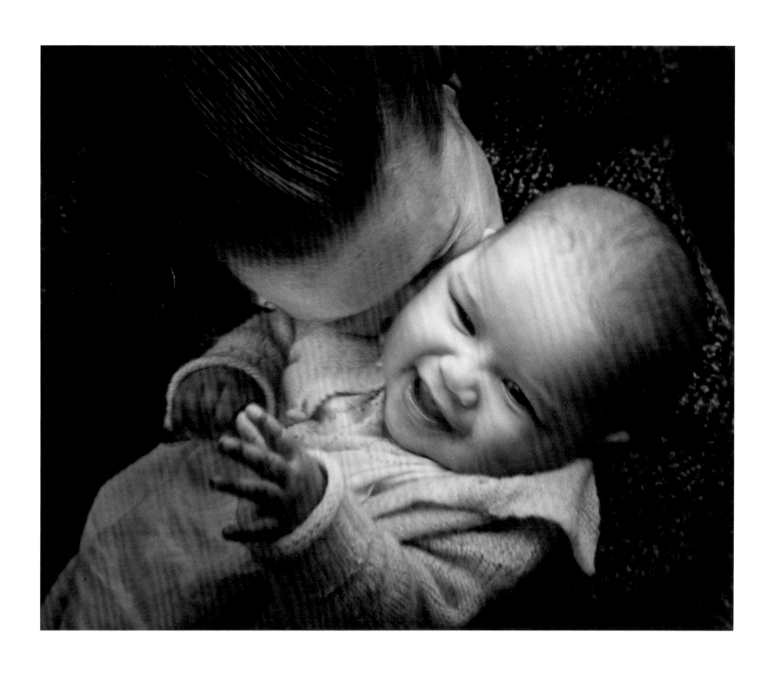

Chao-Chen Yang (1909–1969)
Adoration, circa 1939
Chlorobromide
10 ½ × 12 ¾ in.

Poem written on mat:
"For sky and river in one colour blend,
Without a spot of dust to mar the scene;
While in the heavens above the full-orbed moon
In white and lustrous beauty hangs serene

How many wanderers by to-night's pale moon
Have met with those from whom so long apart:—
As on the shore midst flowerless trees I stand
Thoughts old and new surge through my throbbing heart!"

By Chang Jo-hsu
Tang dynasty

Chao-Chen Yang (1909–1969)
Autumn Moon, circa 1939–40
Chlorobromide
10 × 12 ¾ in.

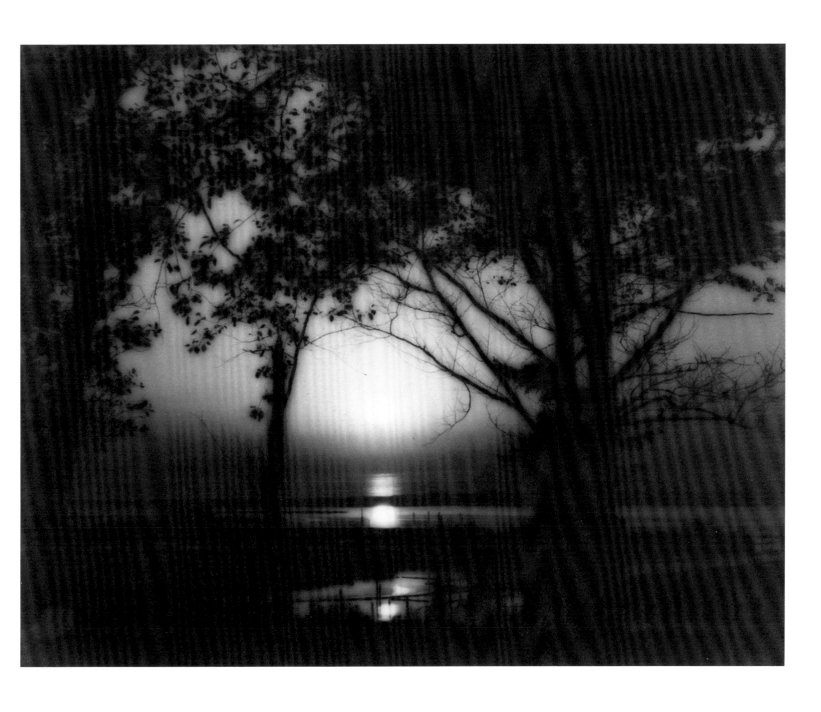

Chao-Chen Yang (1909–1969)
Chastity, 1940
Chlorobromide print with applied
dyes
10 ½ × 13 ½ in.

Chao-Chen Yang (1909–1969)
Untitled, circa 1940
Chlorobromide
10 ¼ × 13 ¼ in.

87

Chao-Chen Yang (1909–1969)
Untitled, circa 1940
Chlorobromide
8 × 10 in.

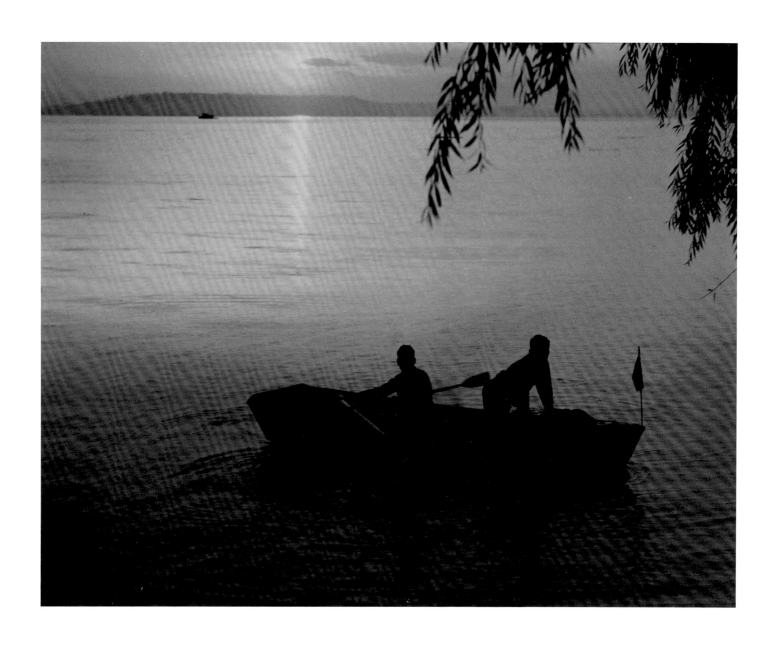

Chao-Chen Yang (1909–1969)
Homeward, circa 1940
Chlorobromide
10 ⅝ × 13 ½ in.

Chao-Chen Yang (1909–1969)
Roaming Pair, circa 1940
Composite print using two negatives,
one for the ducks and the other for
the lake with sunshine, taken on
separate days.
Chlorobromide
13 ½ × 15 ¾ in.
Reproduced in the *American Annual
of Photography*, 1944

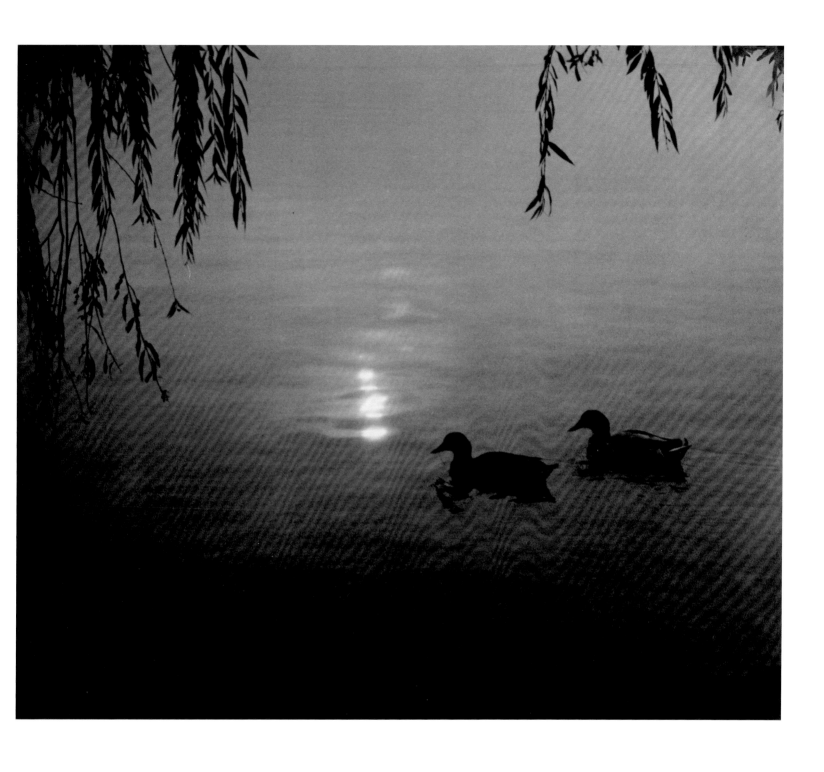

Chao-Chen Yang (1909–1969)
Untitled, circa 1939
Chlorobromide
8 ⅝ × 7 ¼ in.

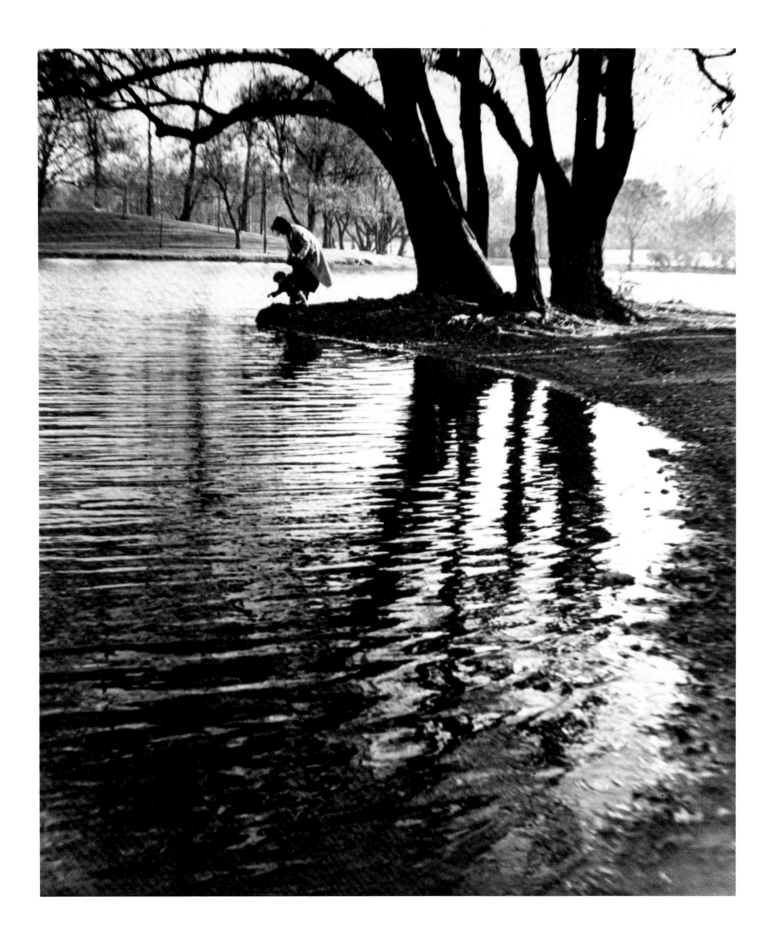

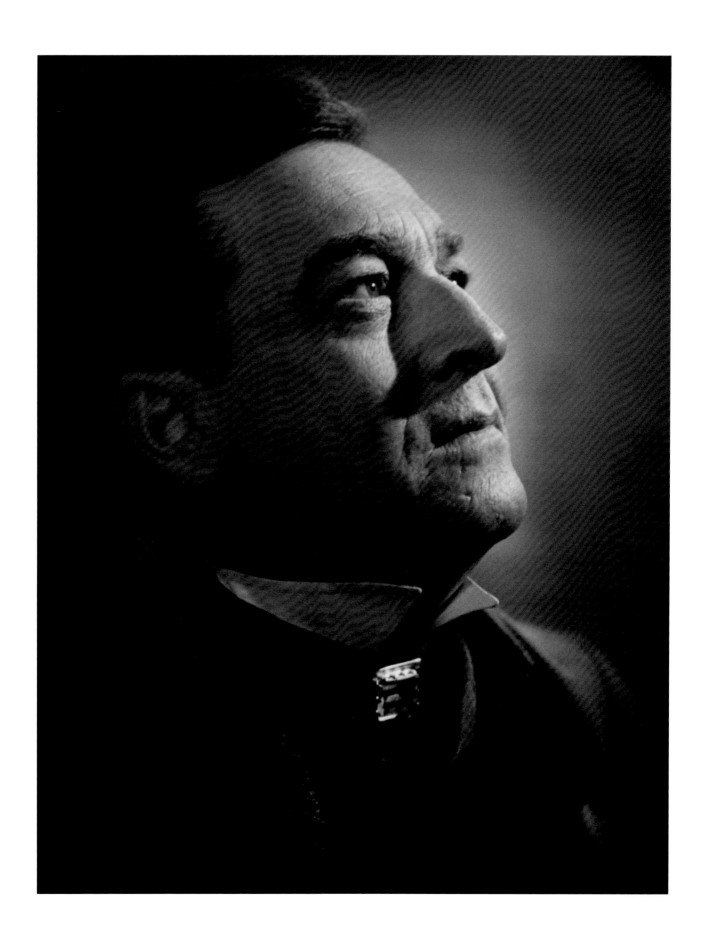

Chao-Chen Yang (1909–1969)
Mr. James (Burton James), circa 1940
Chlorobromide
13 ½ × 10 ½ in.

James and his wife, Florence Bean James, were important figures in the theater history of Seattle and co-founded the Seattle Repertory Playhouse. This photograph was included in the Eighth International Salon of Photography, sponsored by the Pictorial Photographers of America, at the American Museum of Natural History in New York City, 1941.

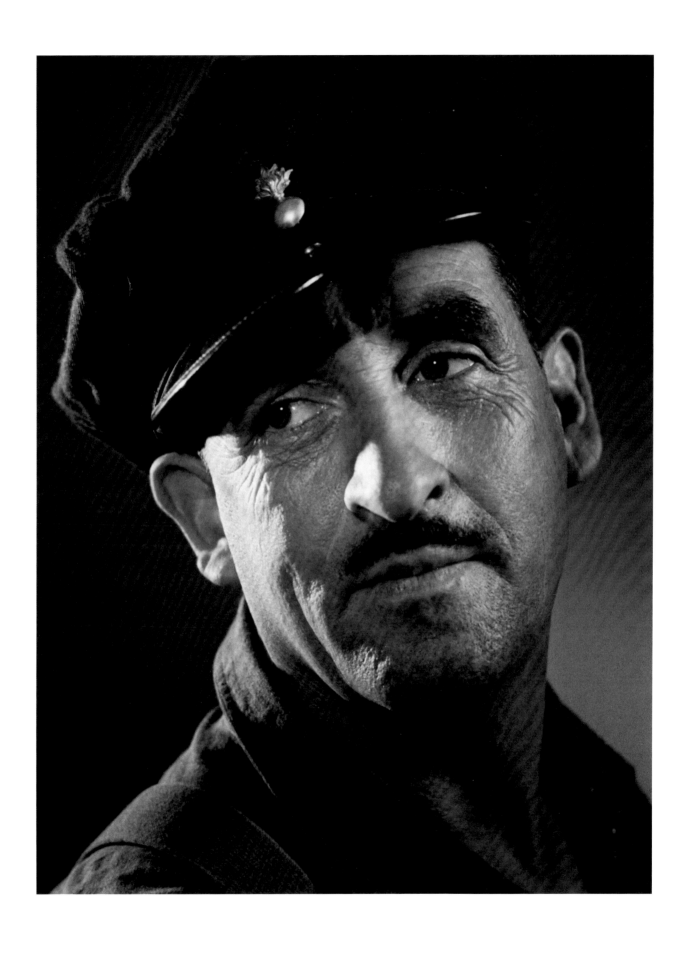

Chao-Chen Yang (1909–1969)
Pat, circa 1941
Chlorobromide
13 ½ × 10 ⅜ in.

The model for this photograph was Yang's friend Frederick Thomas Bookey Sr. His wife,
Gertrude, posed for the photograph *Southerly Wind*.

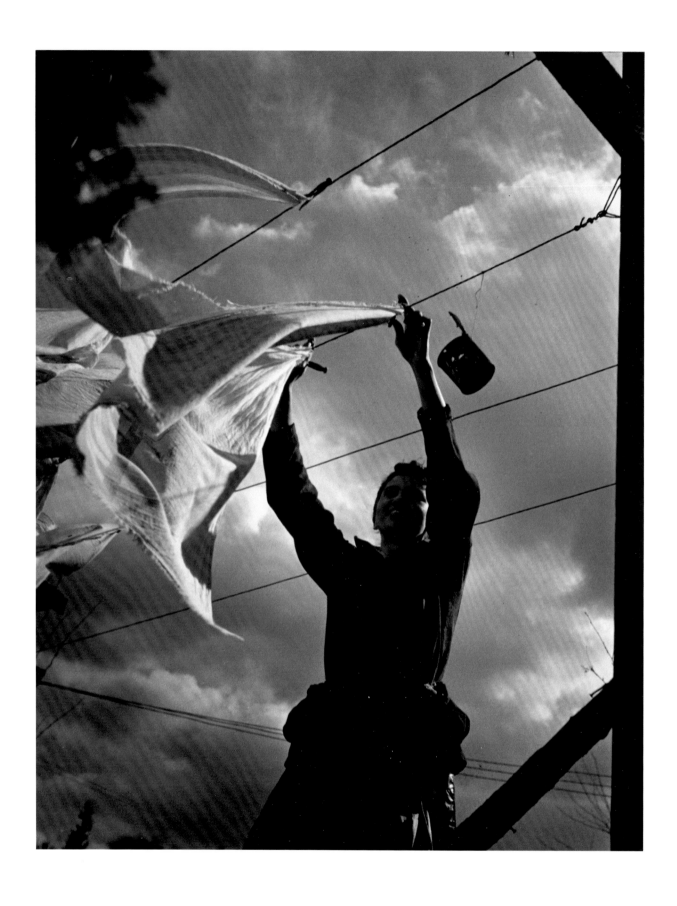

Chao-Chen Yang (1909–1969)
Southerly Wind, circa 1941
Chlorobromide
13 ½ × 10 ⅝ in.

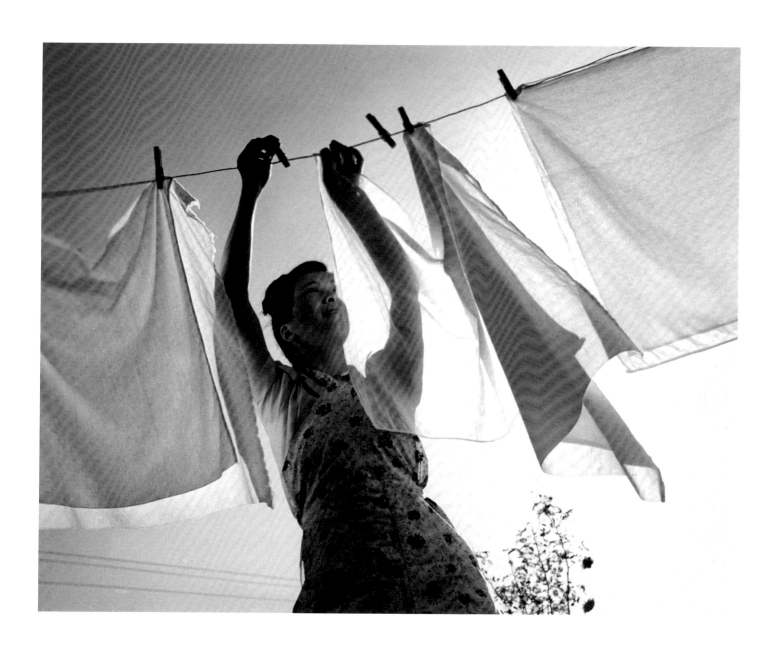

Chao-Chen Yang (1909–1969)
Untitled (Jean hanging clothes), 1941
Gelatin silver
8 × 9 ⅞ in.

97

Chao-Chen Yang (1909–1969)
The Desolate Wheatfield, 1941
Chlorobromide
10 ¾ × 13 ⅜ in.
Tacoma Art Museum, Gift of
David F. Martin and Dominic A.
Zambito, 2009.15.4

First-place prize, Seattle
Photographic Society, March 1941

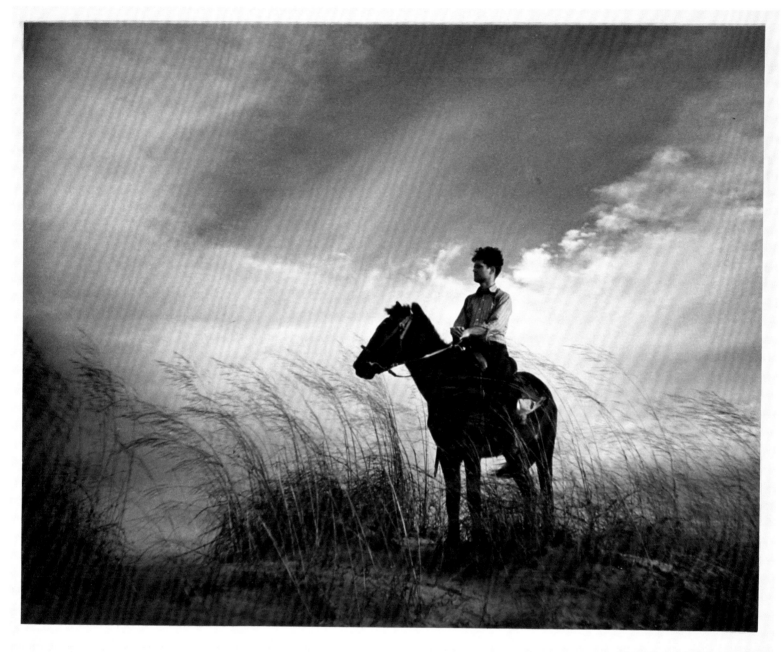

The Desolate Wheatfield Chao-Chen Yang

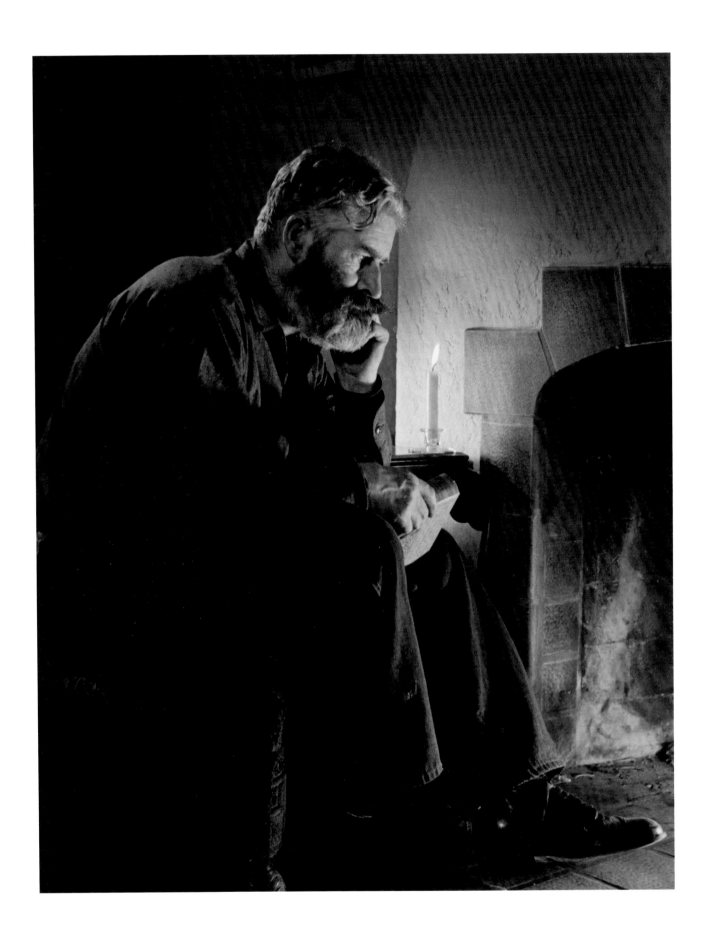

Chao-Chen Yang (1909–1969)
Retrospection, circa 1940–42
Chlorobromide
13 ¾ × 10 ¾ in.

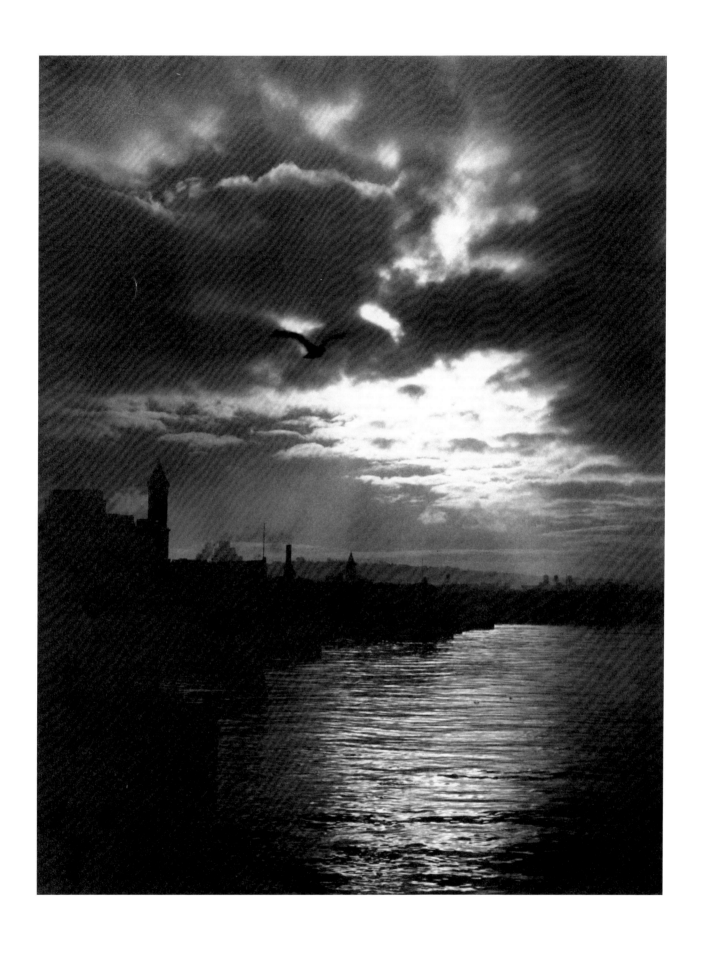

Chao-Chen Yang (1909–1969)
Silvery Gleam, circa 1939–42
Chlorobromide with applied dyes
13 ½ × 10 ½ in.

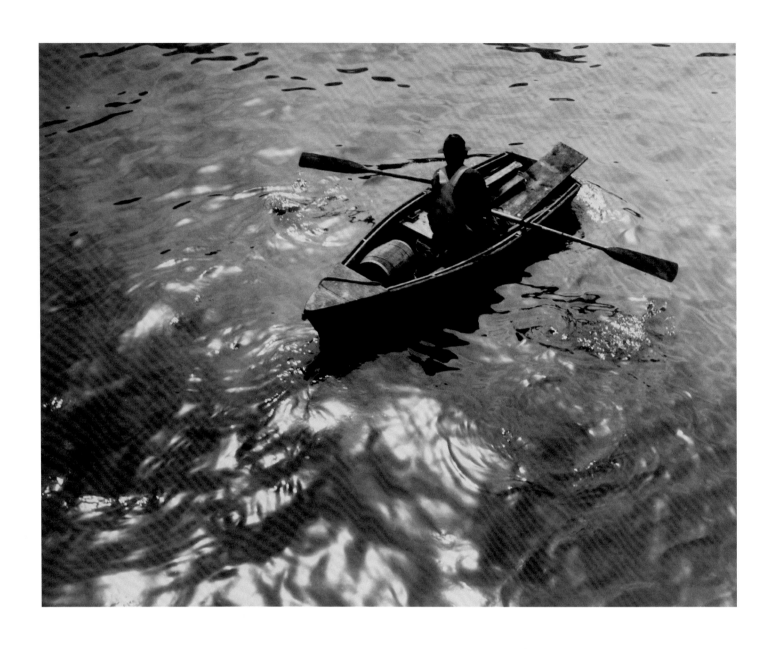

Chao-Chen Yang (1909–1969)
Drifting, circa 1939–42
Chlorobromide with applied dyes
10 ¼ × 13 ⅛ in.

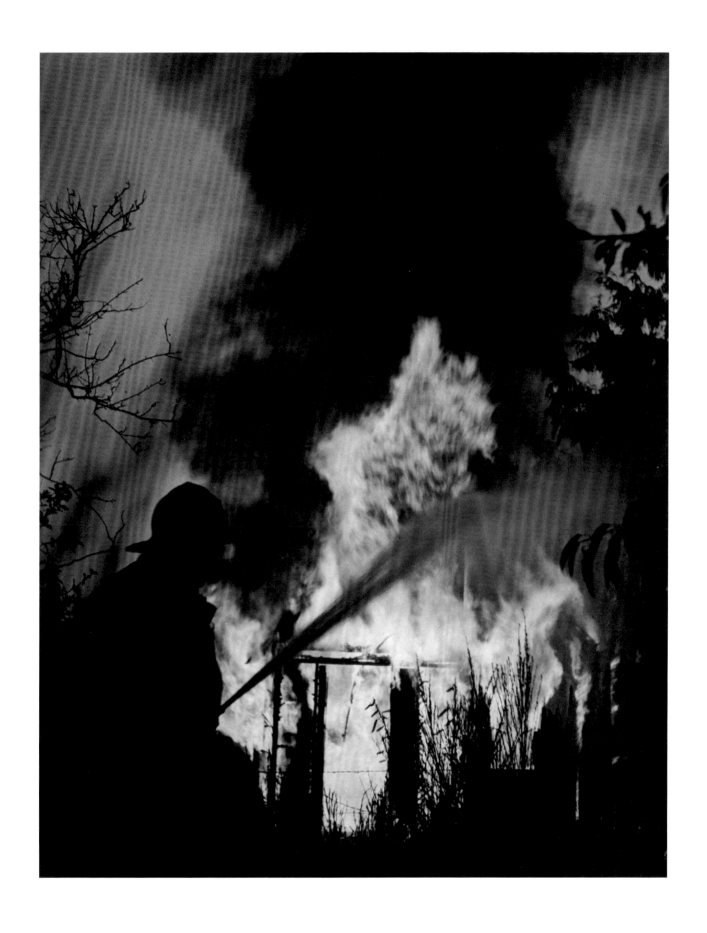

Chao-Chen Yang (1909–1969)
Untitled, circa 1942
Chlorobromide
13 ¾ × 10 ¾ in.

Chao-Chen Yang (1909–1969)
Untitled, circa 1940–42
Chlorobromide
10 ¼ × 12 in.

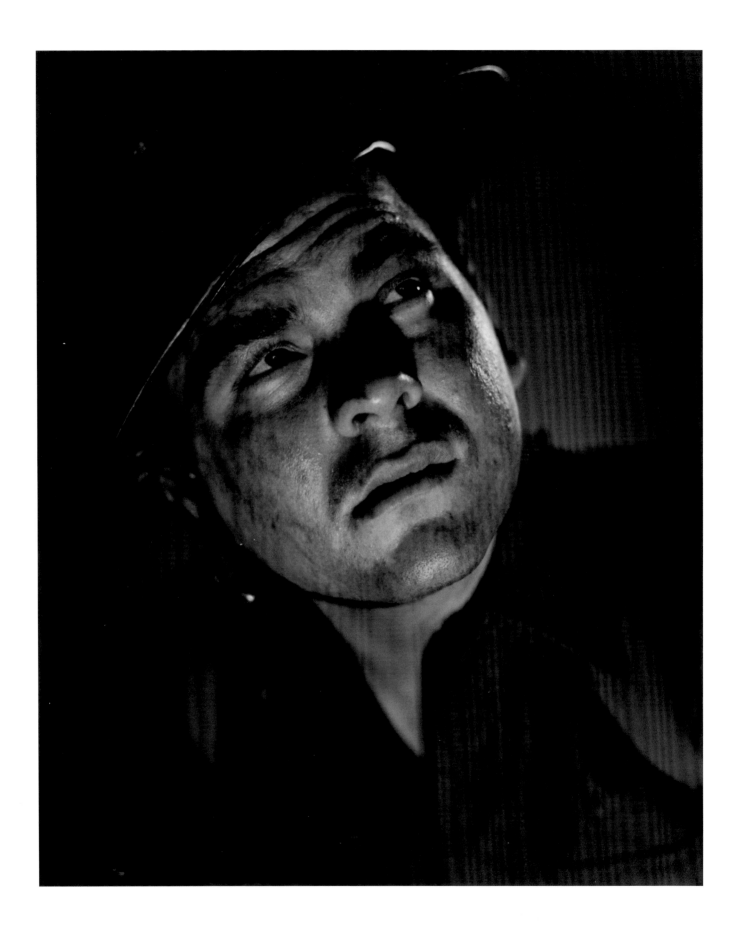

Chao-Chen Yang (1909–1969)
Untitled, 1942
Chlorobromide
16 ¾ × 14 in.

This photograph depicts Staff Sergeant Paul Morton as the subject for a war poster competition sponsored by the Washington State Council of Camera Clubs in October 1942. The competition brought together soldiers, sailors, and Red Cross members as models for the participating photographers, whose prizes were paid in war bonds.

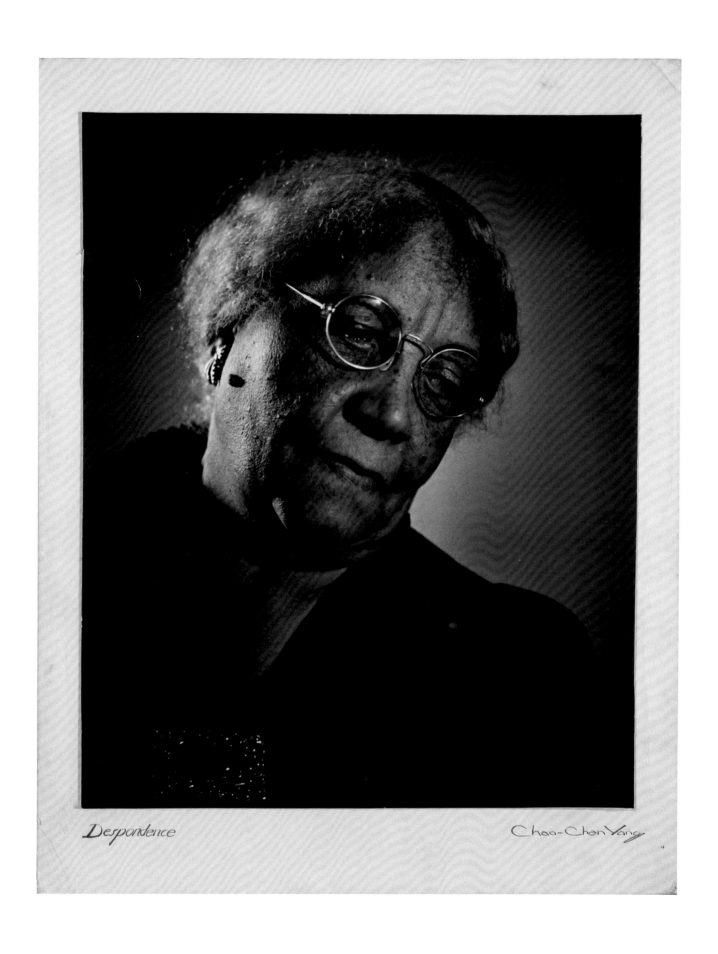

Despondence

Chao-Chen Yang

Chao-Chen Yang (1909–1969)
Despondence, 1942
Chlorobromide
16 ½ × 13 ¾ in.

Chao-Chen Yang (1909–1969)
The Warmth and the Chill, circa 1942
Composite print
Chlorobromide
13 ½ × 10 ½ in.

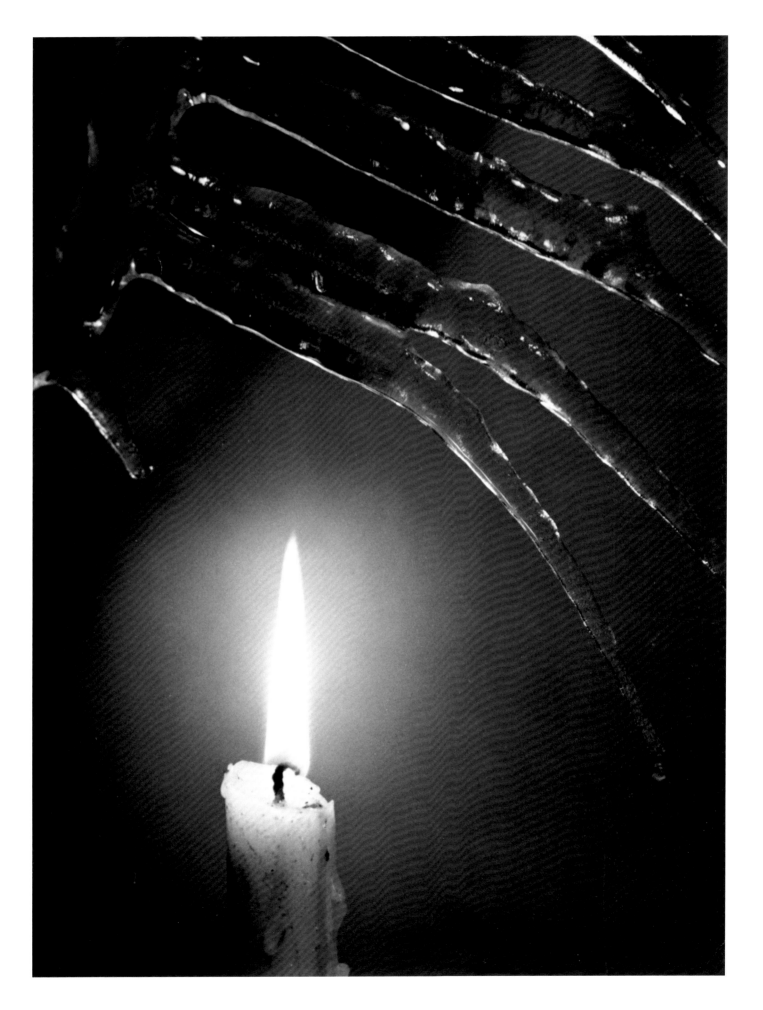

Chao-Chen Yang (1909–1969)
Day Is Ending, circa 1941–42
Composite print using two negatives,
one for the seagull and the other
for the sky and landscape, taken on
separate days.
Chlorobromide
10 ⅝ × 13 ½ in.
Reproduced in the *American Annual
of Photography*, 1945

Chao-Chen Yang (1909–1969)
Untitled (Detail of the Arctic Building,
Seattle), circa 1942
Gelatin silver
16 ¾ × 12 ½ in.

Chao-Chen Yang (1909–1969)
Windswept, circa 1940–42
Chlorobromide
10 ⅜ × 13 ¼ in.

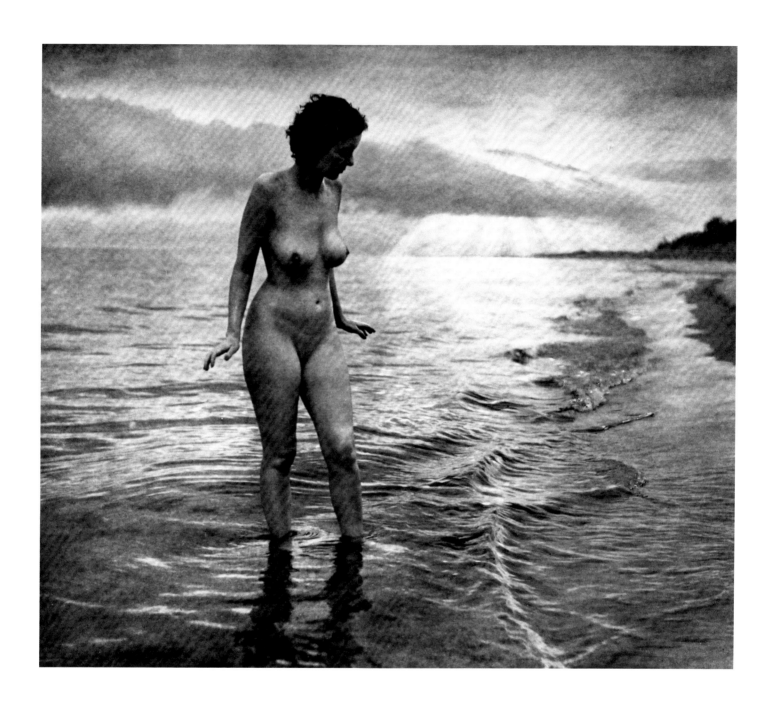

Chao-Chen Yang (1909–1969)
Morning Tide, circa 1940–42
Paper negative print
10 ½ × 12 in.

Chao-Chen Yang (1909–1969)
Dew, circa 1940
Chlorobromide
10 ⅝ × 13 ½ in.
First prize, Seattle Photographic
Society, May 1941

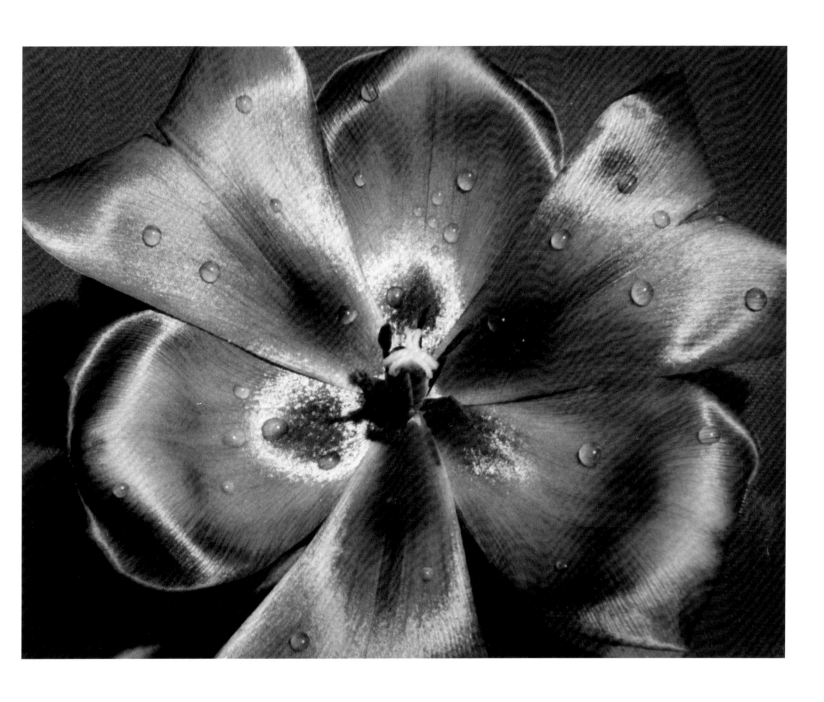

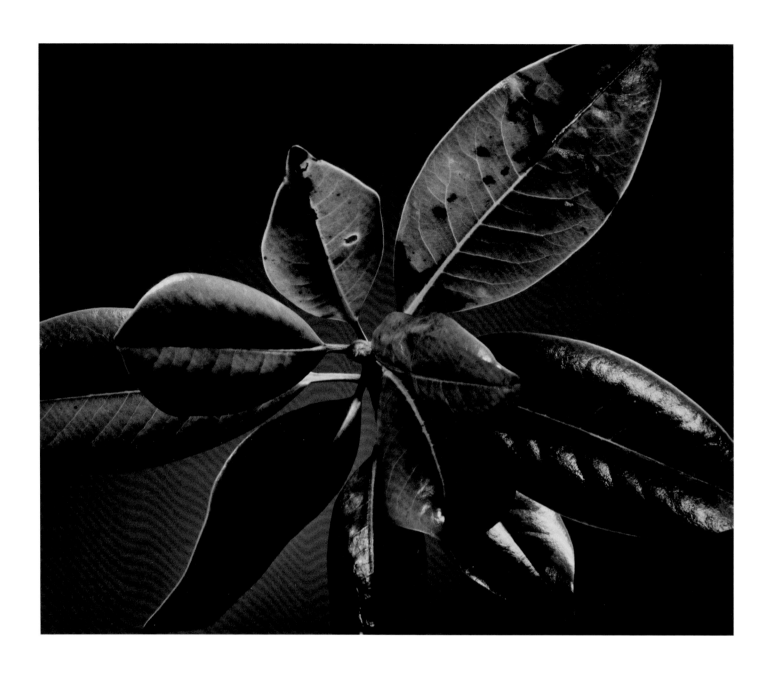

Chao-Chen Yang (1909–1969)
Leaf Pattern, circa 1940–42
Chlorobromide
13 × 16 in.

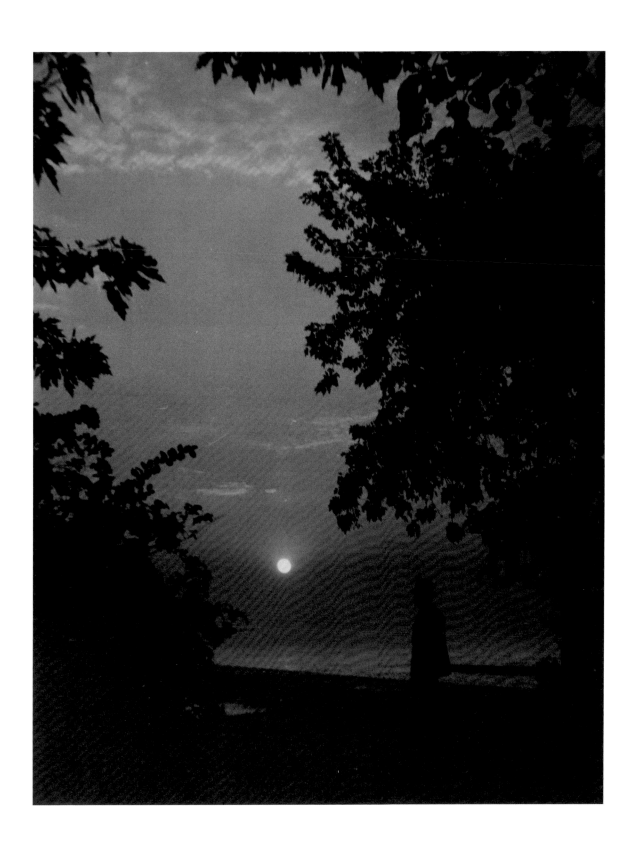

Chao-Chen Yang (1909–1969)
Untitled, circa 1940–42
Chlorobromide
9 ½ × 7 ½ in.

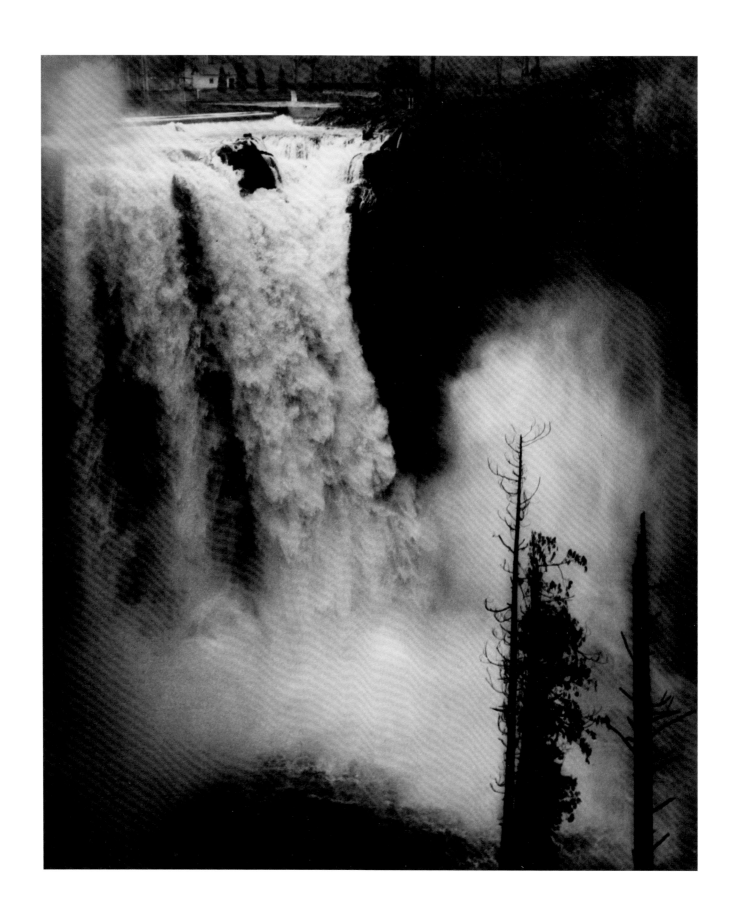

Chao-Chen Yang (1909–1969)
Force and Re-action (Snoqualmie
Falls), circa 1940–42
Chlorobromide
14 ⅞ × 12 ½ in.

Chao-Chen Yang (1909–1969)
Tide Wash, circa 1940–42
Chlorobromide
12 ¾ × 16 ⅜ in.

Chao-Chen Yang (1909–1969)
Autumn Symphony, circa 1940–42
Chlorobromide
10 ½ × 13 ½ in.

Chao-Chen Yang (1909–1969)
Delicious, circa 1940–42
Chlorobromide
13 ⅝ × 16 in.

Chao-Chen Yang (1909–1969)
Green Pastures, circa 1940–42
Chlorobromide
10 ¾ × 13 ¾ in.

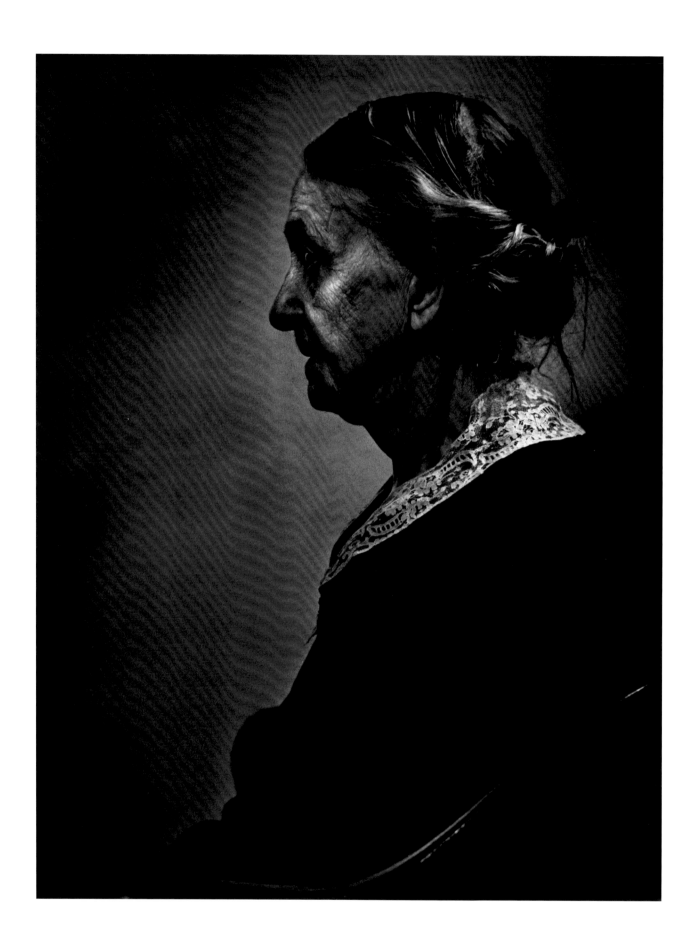

Chao-Chen Yang (1909–1969)
Time Worn, circa 1940–42
Chlorobromide
12 ⅞ × 10 in.

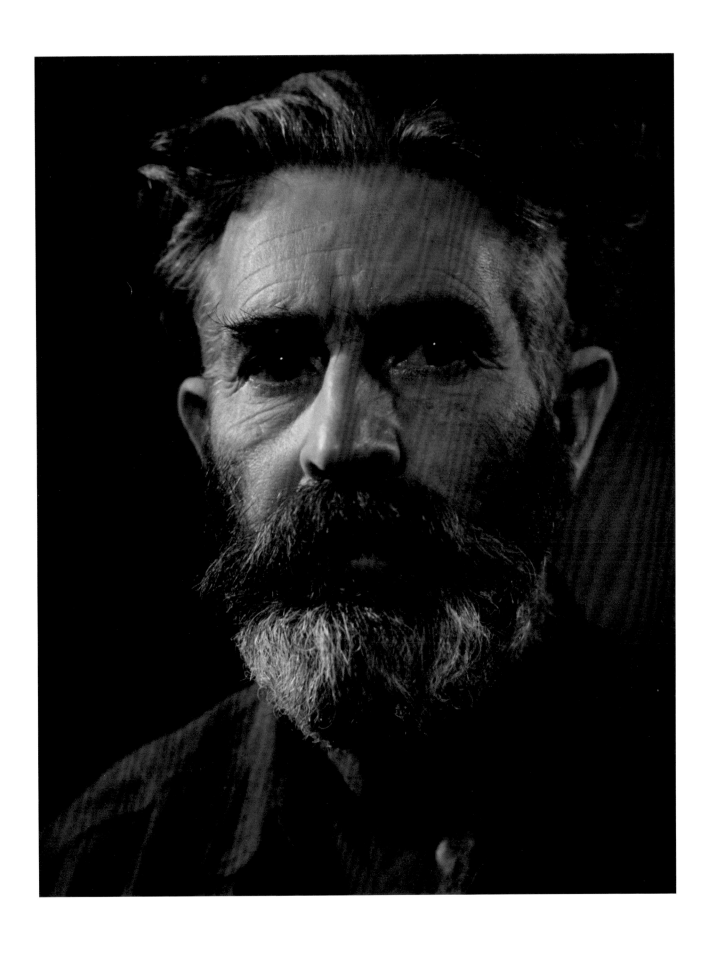

Chao-Chen Yang (1909–1969)
Mac the Pioneer, circa 1940–42
Chlorobromide
13 ½ × 10 ½ in.

Chao-Chen Yang (1909–1969)
The Problem, circa 1940–42
Chlorobromide
16 ⅛ × 13 ¾ in.

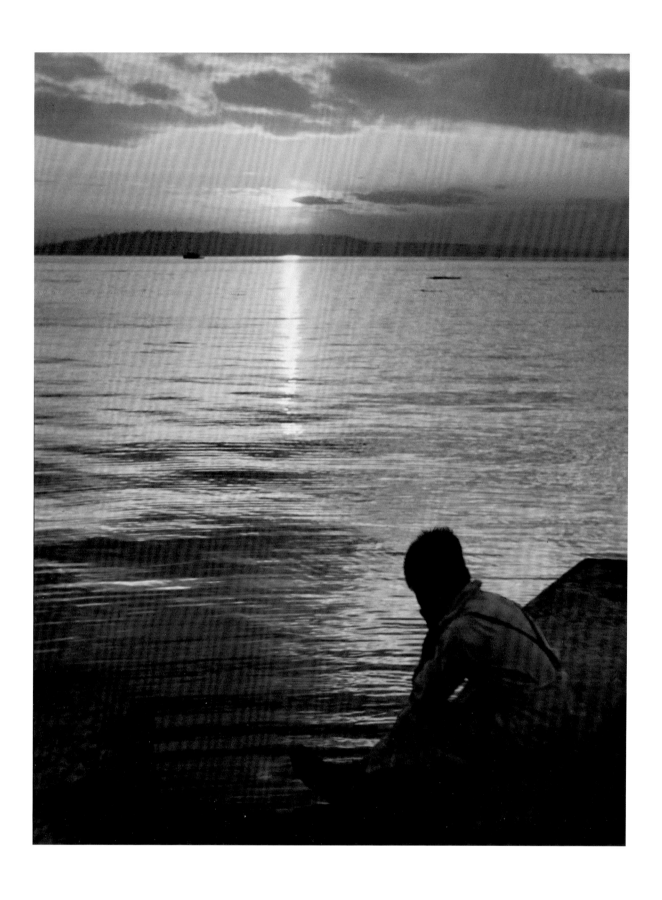

Chao-Chen Yang (1909–1969)
Serenity (Edgar by Puget Sound),
circa 1940–42
Chlorobromide
13 ½ × 10 ½ in.

Chao-Chen Yang (1909–1969)
Rhonda Fleming, 1952
Dye Transfer print
19 × 15 in.

Actress Rhonda Fleming at the Seattle Art Museum during the Seattle premiere of her movie
Hong Kong.
Image of Rhonda Fleming used with permission from her estate.

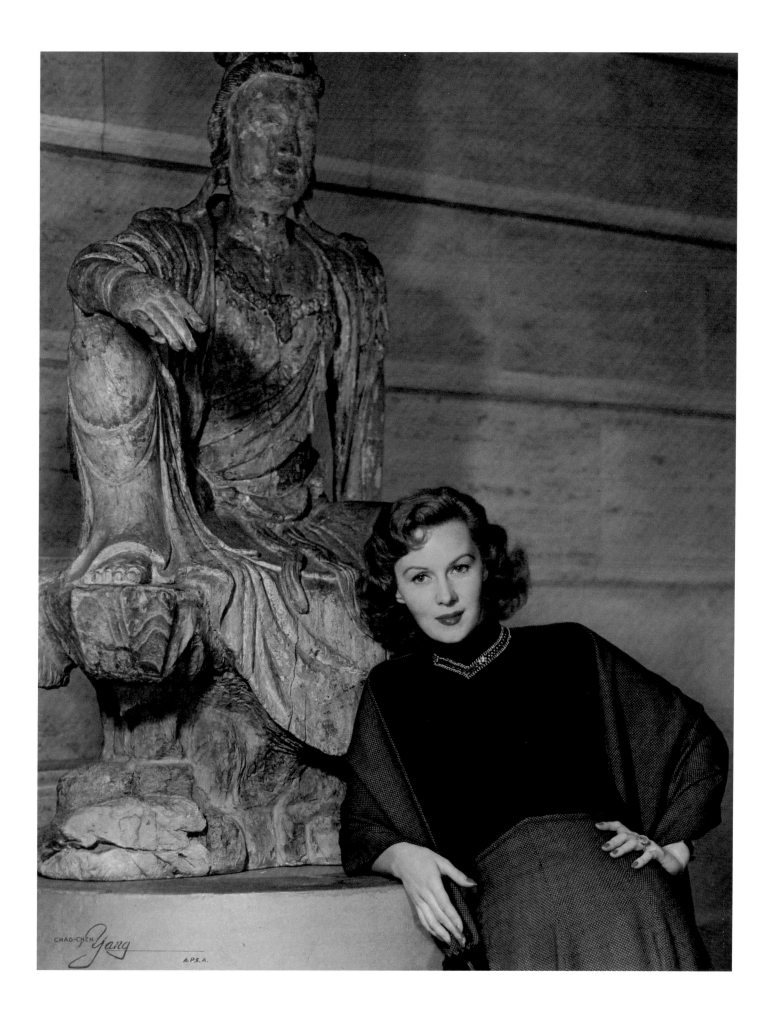

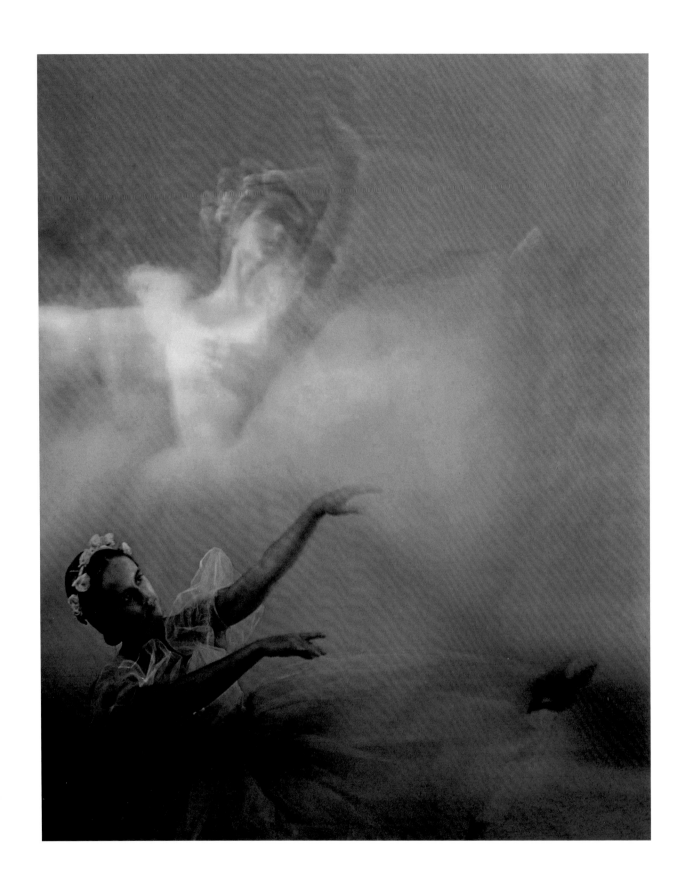

Chao-Chen Yang (1909–1969)
Dream Ballet, circa 1953
Dye Transfer composite print
16 ¼ × 13 in.

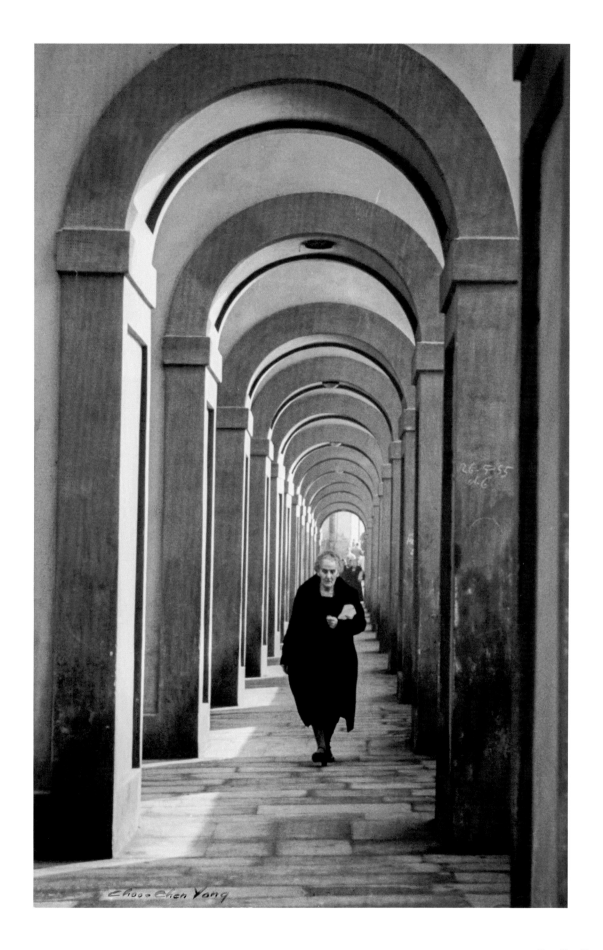

Chao-Chen Yang (1909–1969)
Arcade in Florence, Italy, 1955
Dye Transfer print
19 ½ × 12 ½ in.

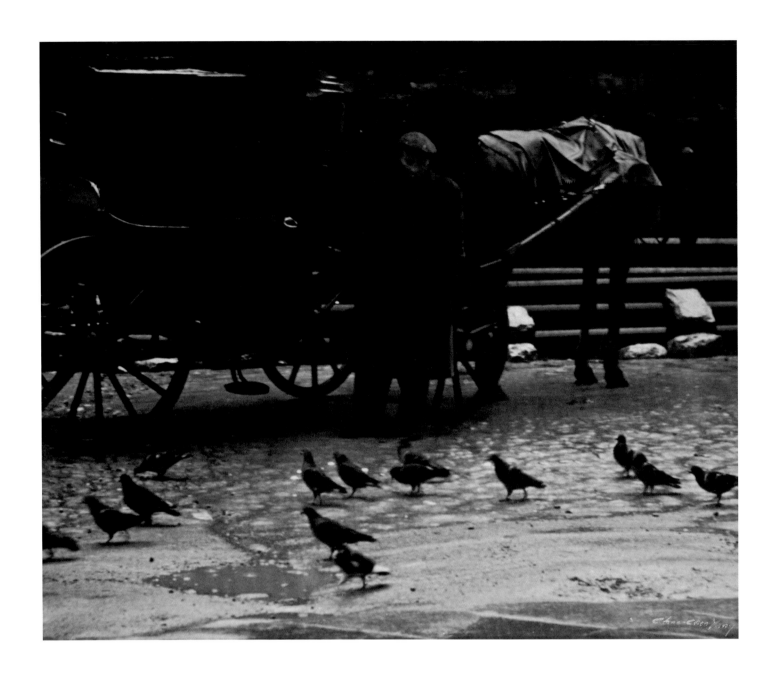

Chao-Chen Yang (1909–1969)
Waiting, Spain, 1955
Dye Transfer print
19 ⅜ × 23 ½ in.

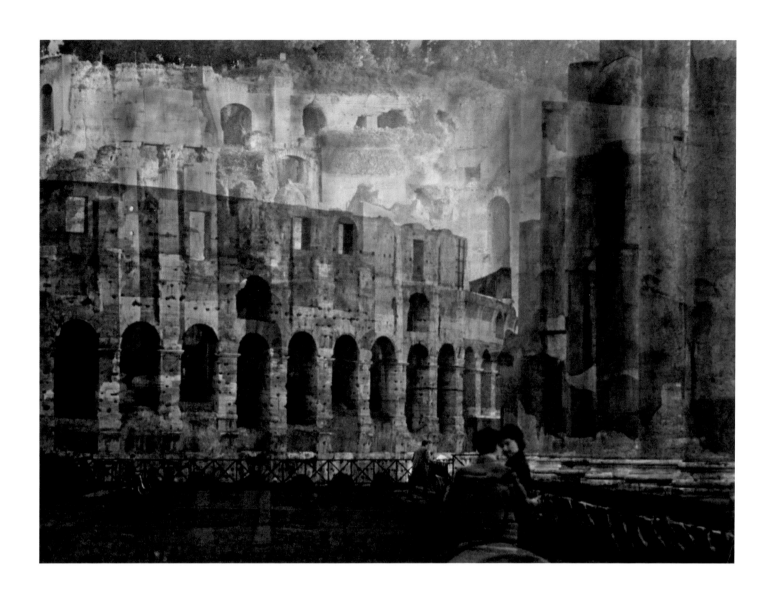

Chao-Chen Yang (1909–1969)
Rome Impression, 1955
Dye Transfer composite print
16 × 22 in.

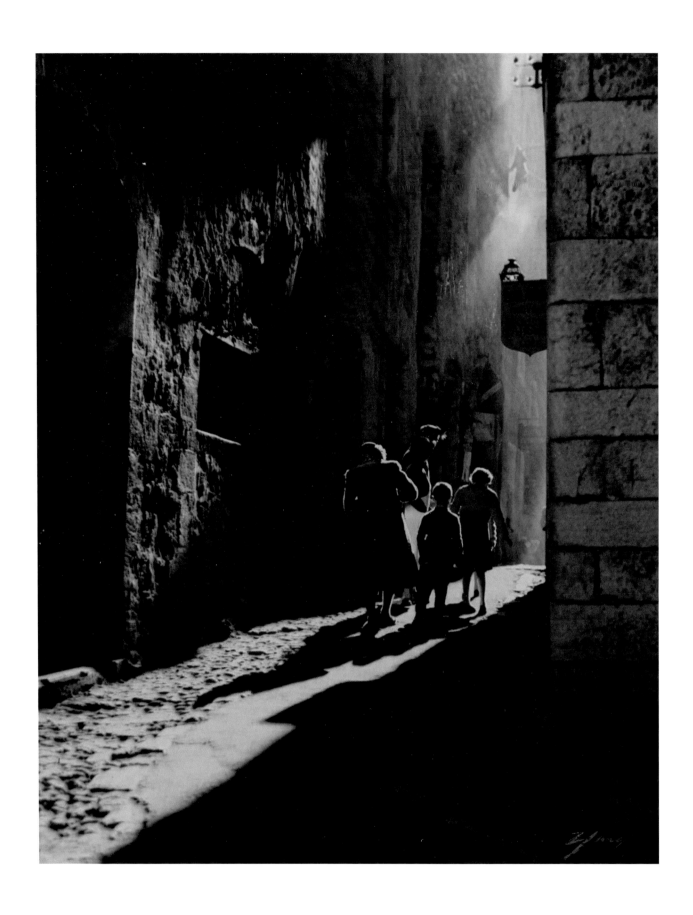

Chao-Chen Yang (1909 1969)
Sharing, France, 1955
Dye Transfer print
17 ¼ × 13 ⅞ in.

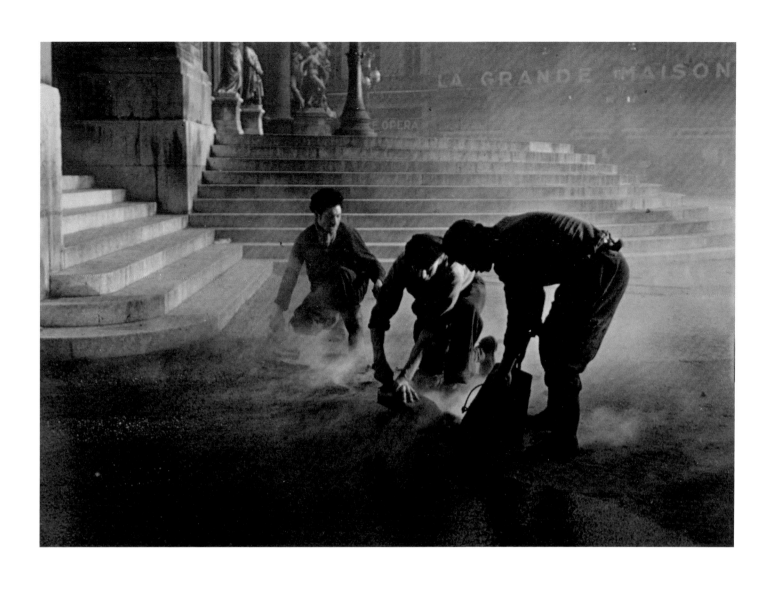

Chao-Chen Yang (1909–1969)
Street Repairs, Paris, 1955
Dye Transfer print
13 ⅜ × 19 in.

Chao-Chen Yang (1909–1969)
In the Rain, Paris, 1955
Dye Transfer print
17 3⁄8 × 14 in.

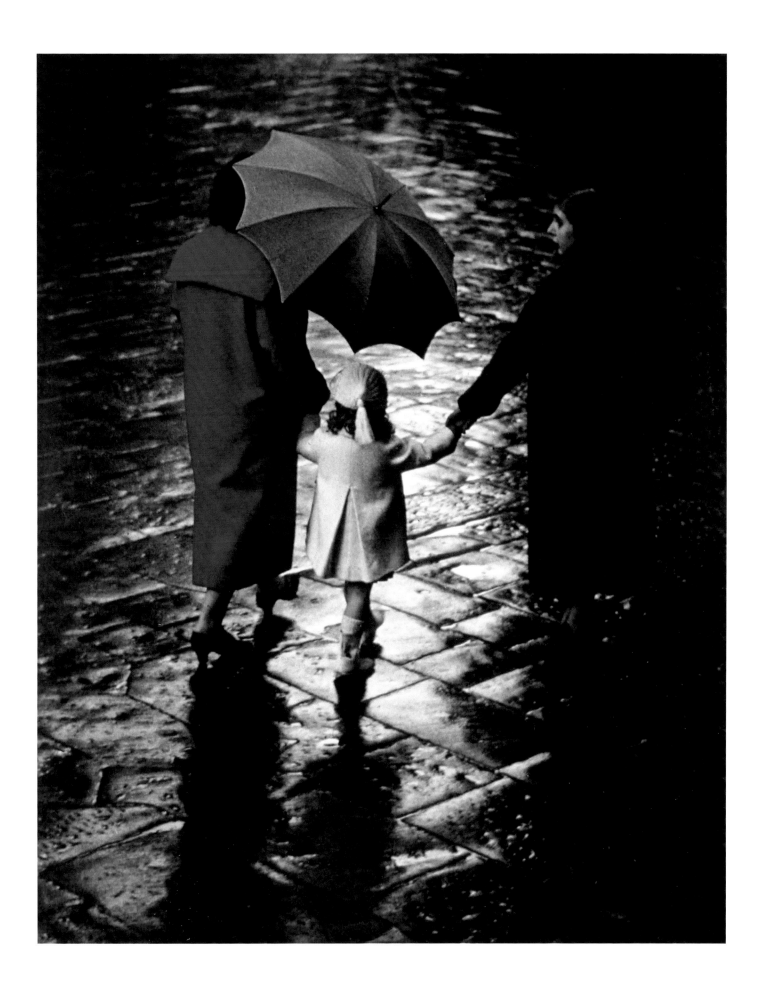

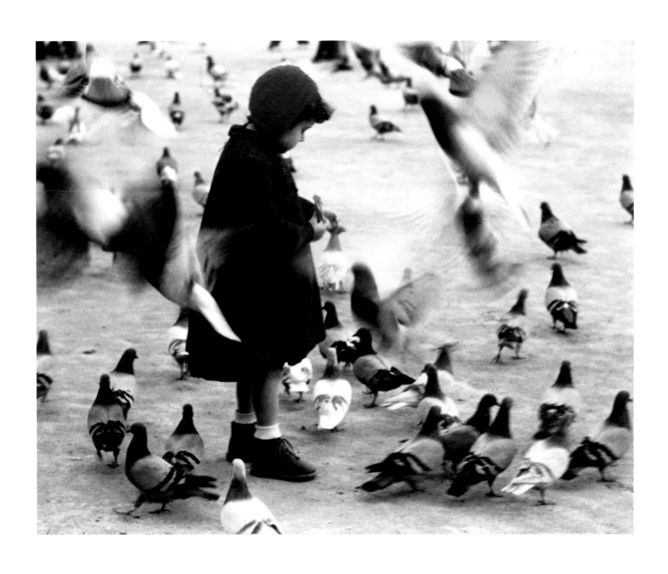

Chao-Chen Yang (1909–1969)
Girl Feeding Pigeons, Spain, 1955
Unknown color process
10 × 8 in.

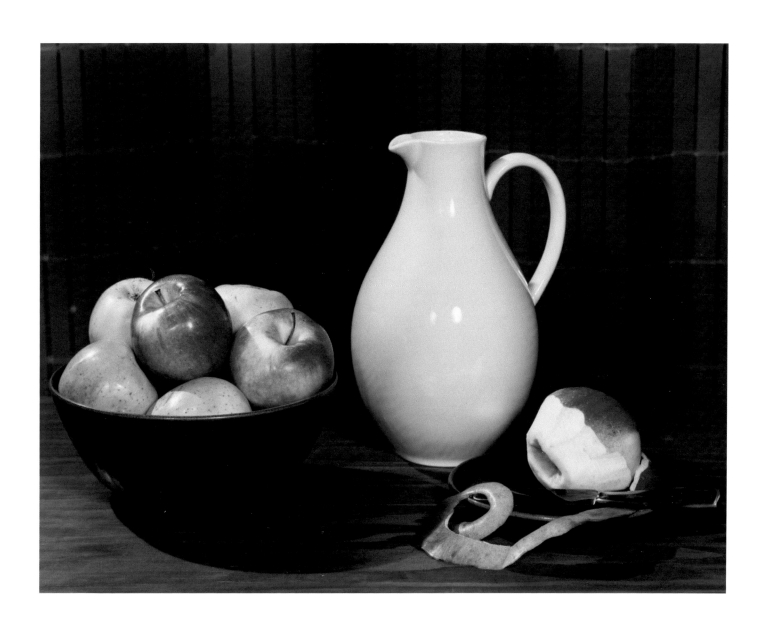

Chao-Chen Yang (1909–1969)
Still Life, 1956
Dye Transfer print
10 ⅛ × 13 ¼ in.

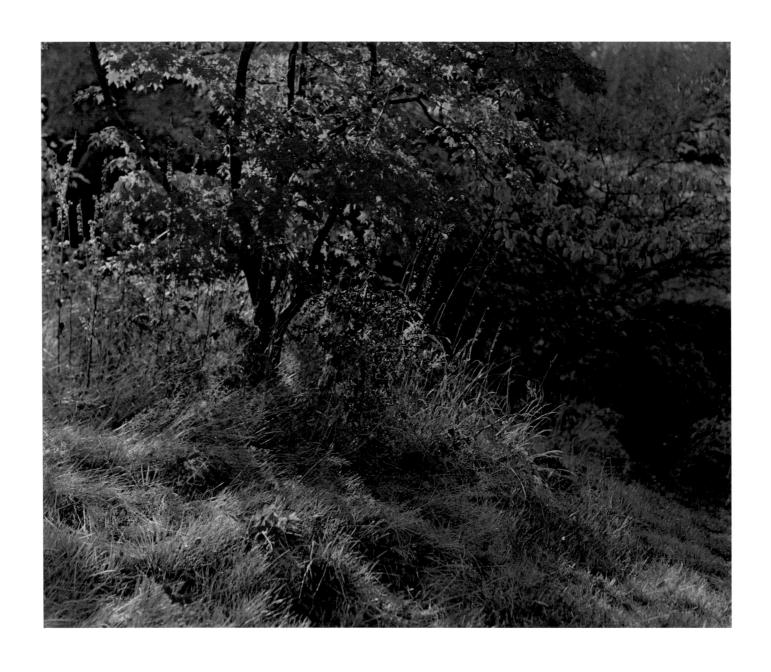

Chao-Chen Yang (1909–1969)
Untitled, circa 1959
Dye Transfer print
13 ½ × 16 ½ in.

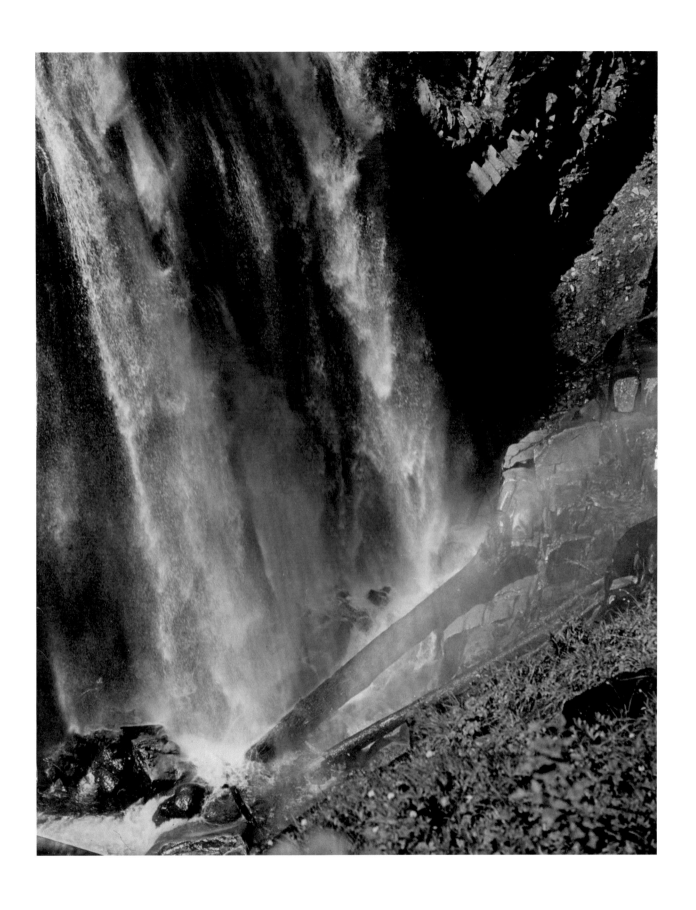

Chao-Chen Yang (1909–1969)
Untitled, circa 1959
Unknown color process
19 ⅜ × 15 ½ in.

Chao-Chen Yang (1909–1969)
Untitled, circa 1959
Dye Transfer print
13 × 19 ⅛ in.

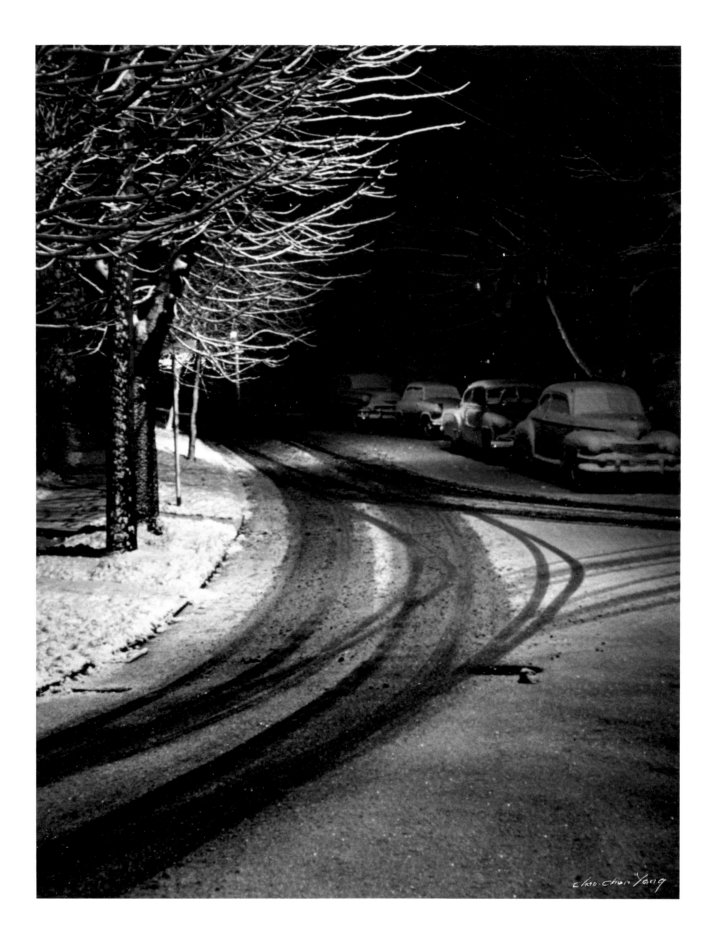

Chao-Chen Yang (1909–1969)
Winter Street, 1961
Dye Transfer print
19 ¾ × 15 ½ in.

Chao-Chen Yang (1909–1969)
Untitled (Space Needle), circa 1962
Light painting photograph
15 ½ × 19 ⅛ in.

One-take, long exposure using simultaneous thin light beams to draw the effect over the image during shooting.
*Thank you to Gimagery for explaining the process

Chao-Chen Yang (1909–1969)
Untitled, circa 1964
Scanned from the original 8 × 10 in.
positive color transparency

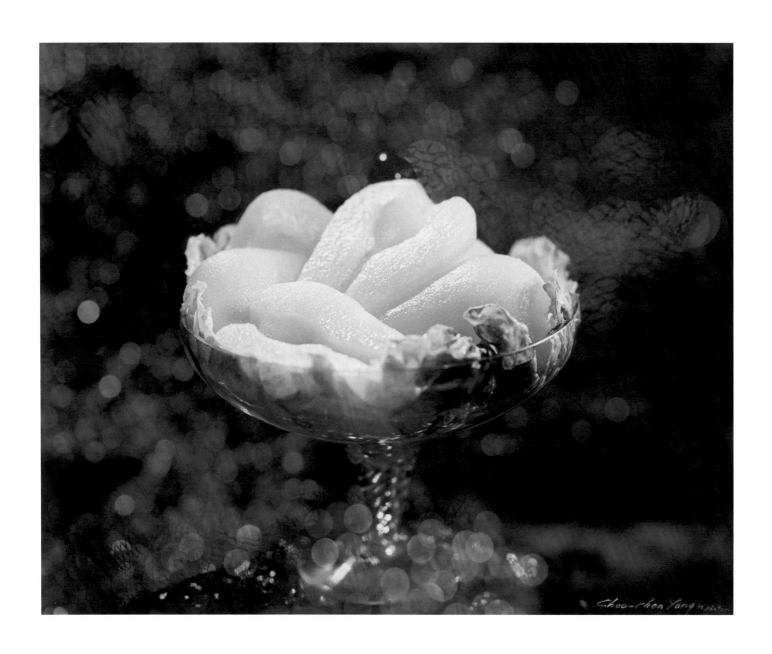

Chao-Chen Yang (1909–1969)
Pears, circa 1964 (Dudley, Hardin,
and Yang)
Dye Transfer print
15 ⅝ × 19 ¾ in.

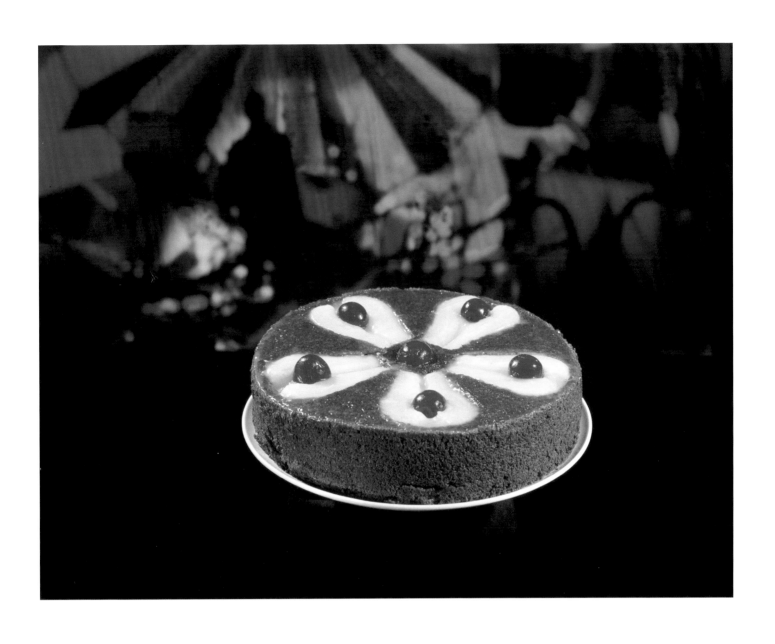

Chao-Chen Yang (1909–1969)
Untitled, circa 1964
Scanned from the original 8 × 10 in.
positive color transparency

Chao-Chen Yang (1909–1969)
Rushing Water, 1967
Dye Transfer print
19 ½ × 23 ⅜ in.

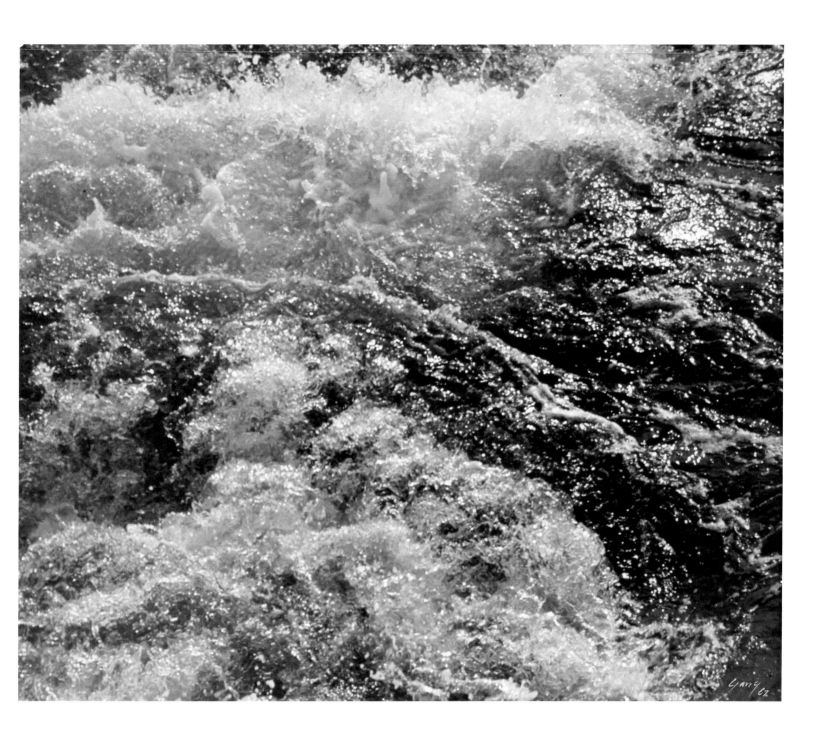

Chao-Chen Yang (1909–1969)
Forest Fire, 1967
Dye Transfer print
16 ½ × 23 ¾ in.

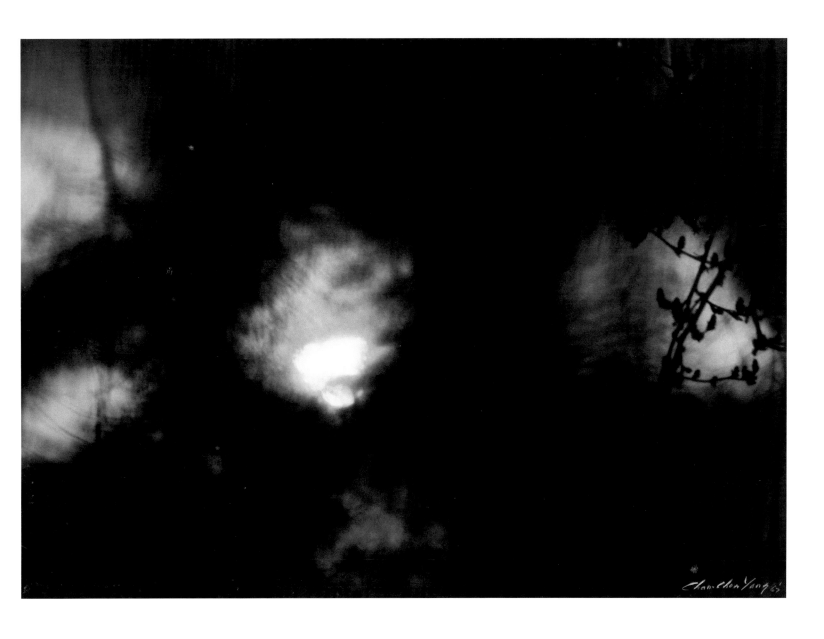

Acknowledgments

I AM ESPECIALLY INDEBTED to Edgar Yang and his wife, Linda, who have given me full access to their family records and provided me with personal insights that I would not have otherwise known. They have treated me like family, and I am honored to call them my friends.

I am grateful to Joan Kee, professor in the history of art at the University of Michigan and the Robert Sterling Clark Visiting Professor at Williams College. Her excellent article "Close-Up: For Asian Lives to Matter; Joan Kee on Chao-Chen Yang's *Apprehension*" appeared in *Artforum* magazine's May 2021 issue, which generated renewed interest in Yang's work.

This project would never have happened had it not been for Cascadia Art Museum. Our museum fills a substantial void in the art history of the Northwest and supports me in my research, curating, and writing. We have become internationally recognized for our groundbreaking exhibitions and publications.

Dominic Zambito, my life partner, provides the support for me to spend endless hours traveling, researching, writing, and making a total mess of our condo. Vous serez récompensé chaque année par des bananes au caramel à Londres.

The board, staff, and volunteers at Cascadia Art Museum.

Phil Kovacevich, who designed this publication and our previous ones. I am always astonished by his talent and his incredible patience.

Jane M. Lichty, whose precise editing expertise was essential to this publication.

Bret Corrington, Artist Eye Portfolio Studio, Seattle, WA, for photographing Chao-Chen Yang's works with such talent and sensitivity.

Sheri Diggins and Alicia Richards of the Seattle Photographic Society, who generously provided me with documents pertaining to Yang's activities with the SPS and saving me a tremendous amount of research time.

My colleagues and friends Dennis Reed and Larry Lytle for assisting me with a better understanding of the color photo processes that Yang used.

I extend my deepest thanks and appreciation to the following:
Spencer Bowman, Northwest Room librarian, Tacoma Public Library, Tacoma, WA
Margaret Bullock, Northwest art historian
Adrian Chiang Bradley for Chinese translations
Dennis Chinn, Estate of Andrew Chinn
Julie Dummermuth, director, School of Art + Design, Ohio University
Lindsey Echelbarger, founder of Cascadia Art Museum and his wife, Carolyn
Ann Ferguson, curator of the Seattle Collection, Special Collections, Seattle Public Library
Paul French, author of *Midnight in Peking*, London, England
Karen Goon, Estate of Goon Dip

Carolin Görgen, associate professor of American studies at Sorbonne Université, Paris

Lauren Hancock, head registrar, Anthropology Collections, Field Museum, Chicago, IL

Kelly Harman and family, Estate of Rhonda Fleming

Melissa Ho, curator of twentieth-century art, Smithsonian American Art Museum

Ellen Ito, artist and curator; Jessica Wilks, interim director of curatorial and head registrar, Tacoma Art Museum, Tacoma, WA

Josie Johnson, Capital Group Foundation Curatorial Fellow for Photography, Cantor Arts Center, Stanford University, Stanford, CA

Marianne Kinkel, associate professor, art history, Washington State University, Pullman, WA

Mia Yinxing Liu, assistant professor, Department of History of Art, Johns Hopkins University, Baltimore, MD

Mike Mieszczak, archivist, E. Urner Goodman Owasippe Museum, Owasippe Scout Reservation, Twin Lake, MI

Nicole F. Mitchell, director, and Caitlin Alcorn, University of Washington Press, Seattle, WA

Steffi Morrison, collections manager, Wing Luke Museum of the Asian Pacific American Experience, Seattle, WA

Michael and Sherry Bookey Murray

Barbara Olson, Boeing Historical Services

Jenn Parent, reference archivist, Museum of Flight, Seattle, WA

Bart Ryckbosch, archivist, Art Institute of Chicago

Shannon Seth, Estate of Austin Seth

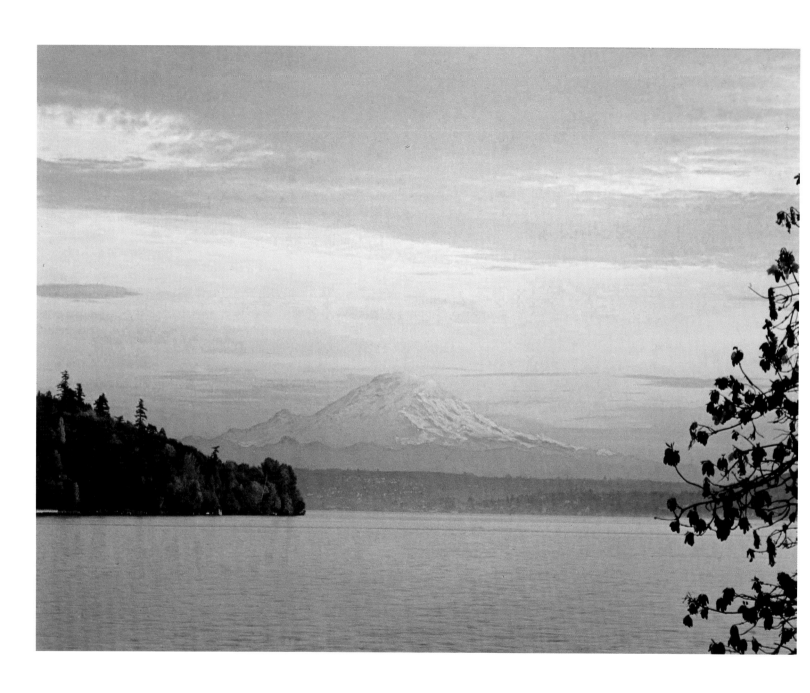

Donors to the Publication

PLATINUM Helen Johnston Foundation
Edgar Yang

GOLD Nancy Rothwell

SILVER Paul Carlson and Shawn-Marie Hanson
Michael Cunningham
Ray and Joan Scheetz

BRONZE David Brewster and Mary Kay Sneeringer
Lindsey and Carolyn Echelbarger
Donald Hall
William and Ruth Ingham
Lawrence Kreisman
Frank and Mary Montgomery Charitable Fund
Lucy and Herb Pruzan
Garratt Richardson

FRIEND Ellen Mohl Barouh and Aaron Barouh
Tom Bingman and Sean Lane
Mark Clatterbuck and Sharon Loper
Sue Dixon
Randall and Jan Holbrook
David McCrae and Suzanne Schweitzer
Tony Valenzuela, in loving memory of Rhonna Donhue
Silvia Waltner, in memory of Nick Waltner

PATRON Sharon Archer and Don Eklund
Ashford Creek Gallery and Museum
Stephen Lacy
Sam and Mary Magill

Chao-Chen Yang (1909–1969)
Mt. Rainier, circa 1949–50
Flexichrome print
12 ⅜ × 16 in.

Full Light and Perfect Shadow: The Photography of Chao-Chen Yang is published in conjunction with an exhibition of the same name, organized by Cascadia Art Museum and on view from November 7, 2023–February 11, 2024.

Front cover: Chao-Chen Yang (1909–1969), *Apprehension* (detail), circa 1949–50, Flexichrome print, 15 ¾ × 12 ½ in.

Back cover: fig. 47. John D. McLauchlan Jr. (1909–1999), Portrait of Chao-Chen Yang reading William Mortensen's book *Pictorial Lighting*, circa 1941, Gelatin silver, 13 ⅞ × 10 ⅞ in.

Frontispiece: Chao-Chen Yang (1909–1969), Untitled, circa 1939, Chlorobromide, 11 ½ × 9 ½ in.

Front endpaper: Chao-Chen Yang (1909–1969), *Autumn Moon* (detail), circa 1939–40, Chlorobromide, 10 × 12 ¾ in.

Back endpaper: Chao-Chen Yang (1909–1969), *Night in Paris Street* (detail), 1955–56, Unknown color process, 13 ½ × 19 ⅜ in.
ISBN 978-0-9989112-5-0
Cascadia Art Museum
190 Sunset Avenue South
Edmonds, WA 98020
cascadiaartmuseum.org

Distributed by University of Washington Press
uwapress.uw.edu

Design: Phil Kovacevich
Editing: Jane M. Lichty

Printed in Canada by Friesens Book Division